★
ICONS

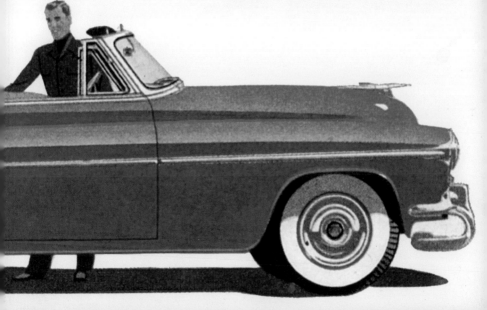

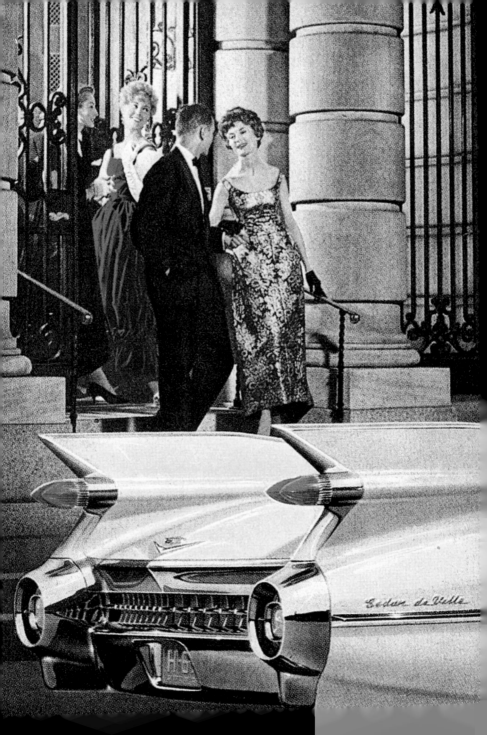

Sedan de Ville

CARS OF THE
50s
VINTAGE AUTO ADS

Ed. Jim Heimann

Introduction by Tony Thacker

TASCHEN

HONG KONG KÖLN LONDON LOS ANGELES MADRID PARIS TOKYO

To stay informed about upcoming TASCHEN titles, please request our magazine at www.taschen.com/magazine or write to TASCHEN, Hohenzollernring 53, D-50672 Cologne, Germany, contact@taschen.com, Fax: +49-221-254919. We will be happy to send you a free copy of our magazine, which is filled with information about all of our books.

© 2009 TASCHEN GmbH
Hohenzollernring 53, D-50672 Köln
www.taschen.com

Original edition: © 2006 TASCHEN GmbH
Editor: Jim Heimann, Los Angeles
Cover design: Sense/Net, Andy Disl and Birgit Eichwede, Cologne
Interior design: Stephen Schmidt / Duuplex, San Mateo
Production: Tina Ciborowius, Cologne
Project management: Julia Krumhauer, Cologne, and Kate Soto, Los Angeles
German translation: Anke Burger, Berlin
French translation: Alice Pétillot, Charenton-le-Pont

Printed in China
ISBN 978-3-8365-1427-9

Hot Rods and Hula Hoops

By Tony Thacker

For much of the world, the 1950s were a drab decade of rebuilding after the devastation of World War II, as documented by the era's black-and-white photographs and newsreels. In stark contrast, the United States economy was booming, and colorful tract housing developments were flourishing across the country. In suburbs such as Levittown, New York, and Lakewood, California, every pastel stucco house had a new color TV flickering in the living room. And as cars became a key part of this new lifestyle, they were saturated with color too.

The war sparked a technology boom in the U.S., giving automakers as well as a growing band of auto enthusiasts mechanical advancements and an unprecedented range of colors to apply to their cars. Though metallic paints were invented in 1935, it wasn't until after WWII that they became readily available—as did pearlescent, candy apple, and Metalflake concoctions. Car colors went from the muted earth tones of the forties to two- and even three-tone paint schemes in bright colors ranging from salmon pink to aqua blue to Titian red. With all assembly lines redirected to military production during the war years, new American models had been few and far between. By 1950, however, major auto manufacturers in Detroit were back in full production mode, and the new paints were convenient for spiffing up prewar models.

The growing range of possibilities inspired many automotive innovations. Ford set the pace with its 1949 models, which sported an innovative new design called uni-body construction, combining body and frame in a single unit. In 1950, the company sold more than three hundred thousand units with a "Fifty improvements for '50" ad campaign, introducing such additions as Powerglide automatic transmission. Chevrolet's sales were even better and topped 1.5 million for the calendar year. In fact, Chevrolet's parent company General Motors (GM) produced more vehicles than all of its competitors combined. By the end of the fifties, the goals set in the 1920s by Alfred P. Sloan, GM's founder, were set in stone: With five divisions—Chevrolet, Pontiac, Oldsmobile, Buick, and Cadillac—there was a model for every income level and every rung on the social ladder.

U.S. automakers were experiencing an industry-wide rejuvenation, and fins and jet engine intakes would become the styling cues that would define the decade. One force behind the new look was Chrysler's young designer, Virgil Exner, who revamped the corporation's staid aesthetic with aeronautics and atomic-age styling, as featured in the sleek New Yorker model. Likewise, GM's Harley Earl, inventor of the ubiquitous tail fin, was inspired by Lockheed's twin-boom P-38 fighter plane. Buick had its own jetsetters—the Electra, DeSoto, Firedome, Firesweep, and Fireflight, all of which were instant hits. Meanwhile, Raymond Loewy, the designer of the curvaceous Coca-Cola bottle, applied his flair to ailing Studebaker and, with assistant Bob Bourke, inked the seminal Starliner Coupe, proclaimed by New York's Museum of Modern Art in a 1953 exhibit to be a "work of art."

Not all the automotive brands that entered with the new decade would survive to see its end. Kaiser-Willys ended its passenger car production in 1955. Hudson, whose Hornet had dominated the early NASCAR scene in 1953 when Marshall Teague won twelve of the thirteen stock car events, was finished by 1957. Packard, the grande dame of luxury cars and one of America's oldest brands, ceased production in 1958. These cars' sluggish sales left their companies without enough return to invest in new design and engineering and unable

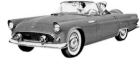

Top: *Pontiac, 1954* Bottom: *Ford Thunderbird, 1955*

to compete in a market that demanded constant innovation.

Of all the fifties clunkers, none was more notorious than the Edsel. Ford announced it would spend more than $250 million designing this new line of cars named after Henry Ford's son. Despite the highly advertised introduction, buyers were turned off by the car's hefty price tag and unflattering design. Although described by Ford as an "an expression of good taste," the so-called horse-collar grille prompted widely circulated wisecracks about its resemblance to the nether regions of the female anatomy. The Edsel lasted a mere three model years and in 1959, its last year of production, only 2,846 cars were built.

Failures aside, technology had raced beyond the world of automobiles and into pop culture. In the movie industry, 1953 saw the introduction of CinemaScope and stereophonic sound, featured in such films as James Dean's bad-boy classic, *Rebel Without a Cause*. Movie and car culture merged with the increasing popularity of the drive-in theater, where moviegoers could watch the silver screen from the comfort of their own cars. Cars could be found on-screen, too, in a new phenomenon called exploitation films, which depicted youth gone wild behind the wheel. *The Devil on Wheels* and *The Wild One* thrilled audiences with stars such as Marlon Brando terrorizing small-town America on choppers and in hot rods.

The year 1953 was also a milestone for Detroit. GM debuted the traveling Motorama auto show, showcasing both current models and dream cars of the future to millions of attendees. The first event was held in New York, and was followed by expos in Miami, Los Angeles, San Francisco, Dallas, and Kansas City. Among the cars unveiled were the Cadillac Le Mans, the Oldsmobile Starfire, and Pontiac's Bonneville Special and Parisienne. None, however, caused as big a sensation as the Corvette, a svelte sports car fabricated in the new medium of fiberglass, featuring what GM styling guru Harley Earl called "power styling." Though first-year sales only amounted to 183 cars, Corvette gained momentum with the American public and was eventually dubbed "America's only true sports car." There was, of course, Ford's response to the Corvette, the Thunderbird, but after just three years as a true two-seater the "T-Bird" became a bloated four-seater sedan.

Much of Chevrolet's success is due to Zora Arkus-Duntov, the man known as the "Father of the Corvette." His 1954 memo to GM management keenly pointed out that the growing youth market demanded performance and style. That same year, Chevrolet introduced the small-block Chevy, with an overhead valve (ohv) V8 engine. Ohvs were considerably more efficient than the side-valve engines that preceeded them, with inlet and exhaust valves placed above the piston for more efficient flow of gases. The ohv V8 engine revolutionized the industry and spawned an aftermarket industry that today is calculated to be worth $30 billion.

Just as performance enthusiasts had loved Henry Ford's flathead V8 of the thirties, a new generation of drivers, who became known as hot rodders, loved Chevy's small block, which produced one horsepower for every cubic inch of capacity. It was cheap, plentiful, and easy to tune for more performance. Soon, these "Mighty Mouse" motors were being retrofitted into hot rods, custom cars, race cars, and boats. "Michigan Madman" E. J. Potter even fitted one into a motorcycle. The small-block Chevy V8 was quicklyubiquitous and begat the muscle car generation of the sixties.

While Chevrolet claimed the lower-priced market, Cadillac retained

Top: *Plymouth, 1954* Middle: *Rambler, 1959* Bottom: *Cadillac, 1957*

top-shelf status. In the style of early coach-built customs, the 1957 Eldorado Brougham was a hand-built, limited-edition sedan. It was America's first completely pillarless four-door and featured a brushed stainless-steel roof. The most expensive car built in America at the time, the sedan also featured such luxuries as silver magnetized glove-box drink tumblers, cigarette and tissue dispensers, a compact with powder puff for the ladies, and an Arpege perfume atomizer by Lanvin. The car was decadence on wheels, but at $13,074—more than double the price of most Caddys—only four hundred were sold.

By decade's end, the tiny fins added by Harley Earl to the 1948 Caddy had grown into giant fins and twin turbine-embellished taillights of the 1959 Eldorado Biarritz. Throughout the fifties, style was king, and Detroit automakers cared little for real mechanical or technological innovation—or safety, so it seemed. What did matter was how the car looked, how much chrome gleamed from its exterior, and how high the fins reached. Yet, as 1960 loomed, the auto world began to change guard. Harley Earl retired in 1959. Virgil Exner was gradually eased out of Chrysler's design team. Cadillac's tail fins couldn't get any higher, and down was the only way to go. In the fifties, color, innovation, and ingenuity reigned supreme, and would pave the way for the sixties' muscle cars and new fleet of compacts.

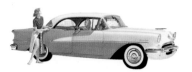

Top: *Oldsmobile, 1958* Bottom: *Oldsmobile, 1955*

Hot Rods und Hula Hoops

Von Tony Thacker

In weiten Teilen der Welt waren die Fünfzigerjahre ein graues Jahrzehnt des Wiederaufbaus nach den Zerstörungen des Zweiten Weltkrieges, zu besichtigen in den Schwarzweißfotos und Wochenschauen aus der Zeit. In totalem Gegensatz dazu florierte die Wirtschaft der Vereinigten Staaten, überall schossen Siedlungen voller ostereierbunter Reihenhäuser aus dem Boden. In Vororten wie Levittown, New York, und Lakewood, California, flackerte in jedem pastellig angestrichenen Haus ein neuer Farbfernseher im Wohnzimmer. Und als Autos zum wesentlichen Bestandteil dieses neuen Lebensstils wurden, waren auch diese knallig bunt.

Der Krieg hatte einen Technologieboom in den USA ausgelöst, durch den Autoherstellern und einer wachsenden Gemeinde von Automobilfans mechanische Neuerungen und eine nie dagewesenen Farbpalette zur Verfügung stand, mit denen die Autos aufgerüstet werden konnten. Metallicfarben wurden zwar bereits 1935 erfunden, aber erst nach dem Zweiten Weltkrieg im Handel angeboten – genau wie Perlglanz, Knallrot und Metalflake-Effektfarben. Für Kraftfahrzeuge wurden jetzt nicht mehr die gedämpften Erdtönen der Vierziger verwendet, sondern zwei- und sogar dreifarbige Lackierungen in einer grellen Farbpalette, die von Lachsrosa über Türkisblau bis zu Tizianrot reichte. In den Kriegsjahren waren sämtliche Fertigungsstraßen für die Militärproduktion eingesetzt worden und neue amerikanische Automodelle insofern eine Rarität gewesen. 1950 standen die wichtigsten Autofirmen in Detroit jedoch wieder voll für die Produktion zur Verfügung und die neuen Lacke kamen gerade recht, um die Vorkriegsmodelle damit aufzumotzen.

Ständig gab es mehr Möglichkeiten, was für ein große Zahl von Innovationen im Automobilbereich sorgte. Ford bildete mit seinen 1949er Modellen die Vorhut. Sie wiesen ein neues Design auf, die so genannte selbsttragende Bauweise, bei der Bodengruppe und Aufbau in einem Stück vereint wurden. 1950 brachte das Unternehmen über dreihunderttausend Wagen mit der Werbekampagne „Fünfzig Verbesserungen für '50" an den Mann, als Neuerungen wie die Powerglide-Automatikschaltung eingeführt wurden. Bei Chevrolet wurden sogar noch mehr Autos verkauft, über 1,5 Millionen in jenem Kalenderjahr. Die Chevrolet-Mutterfirma General Motors (GM) produzierte sogar mehr Fahrzeuge als alle Konkurrenten zusammen. Mit dem Ende der Fünfziger sollte das in den 1920ern von GM-Begründer Alfred P. Sloan formulierte Ziel Realität werden: In den fünf Tochterfirmen – Chevrolet, Pontiac, Oldsmobile, Buick und Cadillac – gab es garantiert ein Modell für jedes Einkommen und jede Stufe auf der sozialen Leiter.

Die gesamte U.S.-Autoindustrie erlebte eine Verjüngungskur, Heckflossen und Düsenjet-Accesoires wurden zu den für das Jahrzehnt charakteristischen Stilmitteln. Eine wichtige Kraft hinter dem neuen Look war der junge Chrysler-Designer Virgil Exner, der dem altbackenen Erscheinungsbild der Marke mit Aeronautik und Atomzeitalter-Ästhetik eine Verjüngungskur verpasste, die besonders an dem schnittigen Modell New Yorker zu sehen war. Harley Earl von GM, Erfinder der allgegenwärtigen Heckflosse, hatte sich von dem Lockheed P-38 Kampfflieger mit doppeltem Heckleitwerk inspirieren lassen. Auch Buick hatte seine „Düsenjets" – den Electra, den DeSoto, den Firedome, den Firesweep und Fireflight, die alle einschlugen wie eine Bombe. Der Designer der kurvenreichen Coca-Cola-Flasche, Raymond Loewy, verwendete seinen guten Geschmack auf den schwächelnden Studebaker und entwarf zusammen mit Assistant Bob Bourke den zukunftsträchtigen Starliner

Oben: *Oldsmobile, 1959* Unten: *Chevrolet, 1959*

Coupe, der vom Museum of Modern Art in New York 1953 zu einem „Kunstwerk" erklärt wurde.

Nicht alle Automobilmarken, die das neue Jahrzehnt einläuteten, überlebten auch bis zu seinem Ende. Kaiser-Willys stellte seine Pkw-Produktion 1955 ein. Hudson, deren Hornet („Hornisse") die frühe NASCAR-Szene völlig beherrscht hatte, als Marshall Teague 1953 zwölf von dreizehn Stock-Car-Rennen gewann, stand 1957 vor dem Aus. Packard, die *grande dame* der Luxuslimousinen und eine der ältesten Marken Amerikas, machte 1958 dicht. Durch den stockenden Absatz dieser Wagen blieb den Unternehmen nicht genug Gewinn, der in die gestalterische und technische Weiterentwicklung hätte investiert werden können, und machte sie so auf einem Markt, der ständige Innovation verlangte, wettbewerbsunfähig.

Von allen Klapperkisten der Fünziger war keine berüchtigter als der Edsel. Ford verkündete, dass über 250 Millionen Dollar in diese neue Modellreihe investiert würde, die nach Henry Fords Sohn benannt war. Trotz hohem Werbeetat bei der Einführung der Wagen wurden die Käufer von dem happigen Preis und wenig ansprechenden Design abgeschreckt. Er wurde zwar von Ford als „Ausdruck guten Geschmacks" beschrieben, doch über den Halskrausen-Kühlergrill wurde gespöttelt, dass er wie eine Klobrille oder Schlimmeres aussehe. Drei Baujahre wurden hergestellt, 1959, im letzten Jahr seiner Produktion, ganze 2.846 Stück.

Doch von diesen Misserfolgen abgesehen hatte der technische Fortschritt nicht nur die Welt der Automobile, sondern auch die Unterhaltungskultur revolutioniert. In der Filmbranche wurden 1953 CinemaScope und Stereosound eingeführt, die in Filmen wie dem klassischen James-Dean-Rebellenfilm *Denn sie wissen nicht, was sie tun* zu bewundern waren. Kino- und Autowelt trafen sich in den immer beliebter werdenden Autokinos, in denen man aus dem komfortablen eigenen Kfz das Geschehen auf der Leinwand verfolgen konnte. Auch in einem neuen Film-Genre, dem „Exploitation Film", kamen jede Menge Autos und Jugendliche vor, die hinterm Steuer zum Tier wurden. Das Publikum genoss den herrlichen Schauder, wenn in *Hot Rod (The Devil on Wheels)* oder *Der Wilde* Stars wie Marlon Brando das kleinstädtische Amerika auf Choppern und aufgemotzten Autos terrorisierten.

1953 war ein besonders wichtiges Jahr in Detroit. GM erfand die reisende Motorama Autoschau, in der Millionen von Besuchern die neuen Modelle und Traumautos der Zukunft vorgeführt wurden. Die erste Schau fand in New York statt, es folgten Ausstellungen in Miami, Los Angeles, San Francisco, Dallas und Kansas City. Dort wurden der Cadillac Le Mans, der Oldsmobile Starfire und der Pontiac Bonneville Special und Parisienne enthüllt. Kein Wagen sorgte jedoch für annähernd so viel Aufsehen wie die Corvette, ein schnittiger Sportwagen mit, wie GM-Kultdesigner Harley Earl es nannte, „Power Styling", der aus dem neuen Material Glasfaser hergestellt wurde. Auch wenn im ersten Jahr nicht mehr als 183 Stück verkauft wurden, legte die Corvette in den Augen der amerikanischen Öffentlichkeit doch bald einen Zahn zu und wurde später als „der einzige echte amerikanische Sportwagen" bezeichnet. Es gab natürlich Fords Antwort auf die Corvette, den Thunderbird, der aber nach nur drei Jahren als echter Zweisitzer zur aufgeblähten, viersitzigen „T-Bird"-Limousine wurde.

Chevrolet hat seinen Erfolg zum Großteil Zora Arkus-Duntov zu verdanken, dem „Vater der Corvette." Sein Schreiben an die GM-Führungsrige 1954 legte prägnant dar, dass der wachsende Jugendmarkt nach Leistung und Stil verlangte. Im selben Jahr

Oben: *Mercury, 1954* Mitte: *Corvette, 1953* Unten: *Plymouth, 1953*

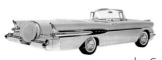

führte Chevrolet den Smallblock Chevy mit OHV-V8-Motor ein. Die Bauweise mit hängenden Ventilen war wesentlich effizienter als die bisherigen Motoren mit seitlich angeordneten Ventilen. Der OHV-V8-Motor revolutionierte die Automobilindustrie und legte den Grundstein für einen Ersatzteilmarkt, der heute auf 30 Mrd. Dollar geschätzt wird.

PS-Fetischisten hatten Henry Fords flachbauenden Zylinderkopf-V8 der Dreißiger geliebt; eine neue Generation von Autofahrern, die als Hot Rodder bekannt wurden, verehrten den Smallblock des Chevy, der für jeden Kubikzoll Hubraum eine Pferdestärke produzierte. Er war billig, überall erhältlich, und leicht zu frisieren. Schon bald wurden diese „Mighty Mouse"-Motoren nachträglich in Hot Rods, Oldtimer, Rennwagen und Boote eingebaut. „Michigan Madman" E. J. Potter verpflanzte sogar einen in ein Motorrad. Der Smallblock Chevy V8 setzte sich schnell durch und wurde zum Urvater der Sechzigerjahre-Generation der „Muscle Cars".

Während Chevrolet den Billigmarkt für sich beanspruchte, blieb Cadillac führend in der Luxusklasse. Im Stil der frühen einzelangefertigten kutschenartigen Modelle war der 1957er Eldorado Brougham eine von Hand gefertigte Limousine mit begrenzter Stückzahl. Es war der erste amerikanische Viertürer ohne B-Säule mit einem Dach aus gebürstetem Edelstahl. Das damals teuerste in Amerika gebaute Auto besaß solche Luxussonderausstattungen wie magnetisierte Whiskygläser aus Silber im Handschuhfach, Zigaretten- und Taschentuchspender, eine Puderdose mit Puderquaste für die Damen und ein Arpege-Parfümzerstäuber von Lanvin. Der Wagen war die reinste Dekadenz auf Rädern, doch beim Preis von 13.074 Dollar – mehr als doppelt so viel wie die meisten Caddys – wurden nur vierhundert Stück verkauft.

Am Ende des Jahrzehnts waren die 1948 von Harley Earl an den Caddy gehängten Miniflösschen beim 1959er Eldorado Biarritz zu gigantischen Heckflossen und doppelten turbinenartig aussehenden Rücklichtern angewachsen. Während der gesamten Fünfzigerjahre regierte das Styling und die Autohersteller in Detroit interessierten sich nur wenig für echte mechanische oder technologische Innovationen – oder Sicherheit, wie man vermuten durfte. Es zählte nur, wie das Auto aussah, wie viel Chrom an der Karosserie blitzte und wie steil die Heckflossen aufragten. Doch mit dem Nahen von 1960 fanden in der Führungsriege der Autowelt Veränderungen statt. Harley Earl setzte sich 1959 zur Ruhe. Virgil Exner wurde allmählich aus dem Chrysler-Designteam verdrängt. Größer konnten die Heckflossen des Cadillac nicht mehr werden – es gab nur noch einen Weg, und das war der nach unten. In den Fünfzigern waren Farbe, Innovation und Einfallsreichtum allbeherrschend und bahnten den Weg für die Muscle Cars der Sechziger und die neue Flotte der Kompaktwagen.

Oben: *Pontiac, 1956* Unten: *Pontiac, 1955*

Grosses cylindrées et Hula Hoops

Par Tony Thacker

Une large partie du monde a vécu les années 1950 comme une terne décennie vouée à la reconstruction après les désastres de la Seconde Guerre mondiale, une période en noir et blanc, à l'image des photos et actualités de l'époque. Le contraste est saisissant avec l'atmosphère qui règne alors aux États-Unis, en pleine expansion économique. Des lotissements couleur bonbon sortent partout de terre et, le long des allées résidentielles de Levittown (New York) ou de Lakewood (Californie), chaque maison de stuc pastel abrite dans son *living room* une télévision couleur flambant neuve. La voiture devient un élément clé de ce nouveau mode de vie et prend elle aussi des couleurs.

L'explosion technologique provoquée aux États-Unis par la guerre fournit aux constructeurs automobiles et à leurs clients de plus en plus nombreux et enthousiastes une vaste palette de progrès mécaniques et de coloris rutilants. Les peintures métallisées sont inventées dès 1935, mais ce n'est qu'après la Seconde Guerre mondiale qu'elles deviennent accessibles au plus grand nombre, tout comme les teintes nacrées, pailletées ou acidulées. Les voitures peuvent dès lors arborer toutes les couleurs possibles, depuis les bruns mats des années 1940 jusqu'aux designs à deux ou trois tons éclatants, du rose saumon au bleu céruléen en passant par le rouge titien. Les nouveaux modèles d'américaines sont rares pendant les années de guerre, les chaînes de montage étant consacrées presque exclusivement à la production d'armement. Mais dès 1950 les grands constructeurs de Detroit ont retrouvé leur productivité et les nouvelles peintures tombent à point nommé pour ravaler les modèles d'avant-guerre.

Cet éventail croissant de possibilités attise les innovations automobiles. Ford lance la tendance avec ses modèles de 1949, qui jouissent d'une construction innovante baptisée *unibody*, parce que carrosserie et châssis sont montés d'un seul tenant. En 1950, grâce à une campagne de promotion élaborée autour du slogan "Cinquante améliorations pour 1950", Ford vend plus de trois cent mille unités équipées notamment de la transmission automatique Powerglide. Les ventes de Chevrolet sont même encore plus spectaculaires puisqu'elles atteignent le million et demi au cours de la même année. De fait, la maison mère de Chevrolet, General Motors (GM), a mis sur le marché davantage de véhicules que tous ses concurrents réunis. À la fin des années 1950, les objectifs qu'avait fixé trente ans plus tôt le fondateur de GM, Alfred P. Sloan, sont atteints. Grâce à ses cinq marques — Chevrolet, Pontiac, Oldsmobile, Buick et Cadillac — la grande maison est capable de fournir un modèle de voiture pour chaque catégorie sociale.

À cette époque, les constructeurs américains bénéficient d'un rajeunissement général de l'industrie ; ailettes et moteurs aussi gourmands qu'un réacteur deviennent les éléments emblématiques de la voiture des *Fifties*. Cette nouvelle allure doit beaucoup au concepteur qui sévit alors chez Chrysler, Virgil Exner, qui redonne un coup de jeune à l'esthétique guindée de la maison grâce à une silhouette empruntée à l'aéronautique et digne de l'ère nucléaire, des contours qu'arbore notamment l'élégant modèle New Yorker. De même, chez General Motors, Harley Earl, premier styliste de voitures de l'histoire et inventeur du fameux aileron, s'inspire notamment des chasseurs Lockheed P-38 à double fuselage. Buick produit aussi quelques *jet-setters* — l'Electra, la

Ci-dessus: *De Soto, 1952* Ci-dessous: *Willys, 1951*

DeSoto, la Firedome, la Firesweep et la Fireflight — qui remportent un succès immédiat. Pendant ce temps, Raymond Loewy, le concepteur de la gironde bouteille Coca-Cola, met ses dons au service de l'agonisante Studebaker et donne naissance, avec le concours de son assistant Bob Bourke, à la célèbre Starliner coupé, élevée au rang d'"œuvre d'art" par le Musée d'Art Moderne de New York au cours d'une exposition de 1953.

Toutes les marques automobiles présentes au début de la décennie n'ont pas survécu jusqu'à son terme. Kaiser-Willys a ainsi mis fin à sa production en 1955. Hudson, dont la Hornet a dominé les débuts de la scène NASCAR en 1953, lorsque Marshall Teague est sorti vainqueur de douze courses sur treize, expire en 1957. La Packard, reine des voitures de luxe et parmi les doyennes des marques américaines, cesse d'être produite l'année suivante. À cause des ventes stagnantes, ces constructeurs n'ont pas pu investir suffisamment dans la conception et dans l'ingénierie pour rester en compétition sur un marché qui exige alors des innovations constantes.

De toutes les épaves des années 1950, la plus connue est sans doute l'Edsel. Ford avait annoncé un budget de plus de 250 millions de dollars pour la conception de cette nouvelle ligne baptisée en l'honneur du fils d'Henry Ford. Malgré un lancement à grand renfort de publicité, les acheteurs sont rebutés par son prix élevé et son allure peu flatteuse, et alors que Ford l'avait présentée comme "une expression du bon goût", sa grille horizontale fendue d'un radiateur vertical lui vaut d'être comparée aux parties basses de l'anatomie féminine par un grand nombre de petits malins. La Ford Edsel n'est déclinée qu'en trois modèles en autant d'années, jusqu'en 1959, où elle n'est construite qu'à 2 846 exemplaires.

Ces quelques échecs mis à part, la technologie opère des bonds en avant spectaculaires dans d'autres domaines de la culture populaire que le monde automobile. En 1953, l'industrie du cinéma voit l'arrivée du CinemaScope et du son en stéréo, des techniques utilisées notamment dans *La Fureur de vivre*, avec James Dean dans le rôle du rebelle type. Le goût pour les films et pour les voitures modèle une culture nouvelle symbolisée par le succès croissant des *drive-ins*, dans lesquels les cinéphiles peuvent succomber aux plaisirs du grand écran tout en profitant du confort de leurs voitures. Des voitures que les amateurs retrouvent aussi à l'écran, dans ces nouveaux "films d'exploitation" qui mettent en scène une jeunesse aussi débridée que les moteurs des bolides qu'elle conduit. Des films comme *The Devil on Wheels* (Crane Wilbur, 1947) ou *L'Équipée sauvage* (*The Wild One*, Laslo Benedek, 1953) laissent les foules sous le charme de vedettes comme Marlon Brando, qui sèment la terreur dans l'Amérique provinciale en chevauchant choppers et grosses cylindrées.

L'année 1953 est aussi déterminante pour Detroit. GM lance le salon de l'automobile itinérant Motorama, qui présente à des millions de visiteurs des modèles actuels mais aussi de fantasmatiques voitures du futur. Le premier salon est organisé à New York et se déplace ensuite à Miami, Los Angeles, San Francisco, Dallas, et Kansas City. Parmi les voitures dévoilées à cette occasion se trouvent la Cadillac Le Mans, l'Oldsmobile Starfire, la Bonneville Special ou la Parisienne de Pontiac. Mais celle qui crée la sensation, c'est la Corvette, voiture de sport fuselée en fibre de verre, un tout nouveau matériau, et parangon de ce que le gourou de GM Harley Earl a appelé le *power styling*. Seulement 183 unités sont vendues la première année, mais la Corvette finit par gagner le cœur du public américain pour devenir "la

seule véritable voiture de sport américaine". Ford lui oppose bien sûr assez vite une rivale, la Thunderbird, mais cette dernière ne conserve ses deux places que trois ans avant de se transformer en *sedan* pour quatre. Chevrolet doit sont succès, pour une large part, au talent de Zora Arkus-Duntov, l'homme connu comme le "Père de la Corvette".

Ci-dessus: *Nash, 1950* Ci-dessous: *General Motors, 1952*

La note qu'il rédige en 1954 pour la direction de GM insiste avec vigueur sur le fait que les jeunes, qui représentent un marché de plus en plus alléchant, exigent à la fois performance et style. La même année, Chevrolet lance la Chevy *small-block*, équipée d'un nouveau moteur V8 à soupapes en tête, considérablement plus économique que les moteurs à soupapes latérales qui l'ont précédé, les valves d'admission et d'échappement étant montées au-dessus du piston pour une meilleure circulation des gaz. Le moteur V8 à culbuteurs a révolutionné l'industrie automobile et alimenté un secteur post-marché aujourd'hui évalué à 30 milliards de dollars.

De même que les fanatiques de la performance avaient adoré le V8 à tête plate créé par Henry Ford dans les années 1930, une nouvelle génération de conducteurs, regroupés sous le nom de *hot rodders*, se pâme pour le V8 culbuté de cette Chevy, qui produit une puissance de 170 chevaux pour 265 pouces cubes. Elle est peu chère et il est facile de la modifier pour la rendre plus performante. Très vite, ces moteurs dits *"Mighty Mouse"* équipent les Hot rods, les voitures personnalisées, les voitures de courses, voire des bateaux. E. J. Potter, surnommé le "Dingue du Michigan", en monte même un sur une moto. Le V8 *small block* devient vite omniprésent et donne naissance à la nouvelle génération de voitures musclées des années 1960.

Tandis que Chevrolet prend possession du marché des bas prix, Cadillac conserve sa primauté sur le très haut-de-gamme. Fidèle à la carrosserie basse et élancée qui fait sa marque, l'Eldorado Brougham de 1957 est une *sedan* fabriquée à la main en édition limitée, avec un toit en acier inoxydable. Elle est la première quatre-portes américaine sans pied de caisse et aussi la plus chère des voitures construites aux États-Unis à cette époque. Elle bénéficie également de toute une gamme de gadgets de luxe comme des gobelets en argent magnétiques dans la boite à gants, des distributeurs de mouchoirs en papier et de cigarettes, un ensemble rouge à lèvres et poudrier avec miroir pour les dames et même un flacon de parfum Arpège de Lanvin. Cette voiture, c'est la décadence sur roues, mais à 13.074 dollars — soit un prix deux fois plus élevé que celui de la plupart des autres Cadillac — elle n'est vendue qu'à quatre cent exemplaires.

À la fin de la décennie, les petites ailettes ajoutées par Harley Earl à la Caddy de 1948 ont pris de l'ampleur : l'Eldorado Biarritz de 1959 arbore des ailerons de jet géants et une calandre arrière formée de trois rangées de minis-obus qui encadre les feux arrière.

Pendant les années 1950, le style est roi et les constructeurs se soucient semble-t-il assez peu d'y adjoindre de réelles innovations mécaniques, technologiques ou de sécurité. Ce qui compte avant tout, c'est l'allure de la voiture, l'éclat des chromes et l'envergure des ailerons. Pourtant, à l'orée des années 1960, le monde automobile doit se résoudre à accueillir la relève. Harley Earl prend sa retraite en 1959. Virgil Exner est progressivement mis à l'écart de l'équipe de stylistes de Chrysler. Les ailerons arrière des Cadillac ne peuvent pas monter plus haut : il n'y a plus qu'à rétrograder. Les *Fifties* ont été la décennie du triomphe de la couleur, de l'innovation et de l'ingéniosité et ont ouvert la voie aux voitures gonflées et aux compactes des années 1960.

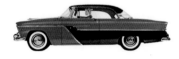

Ci-dessus: *Budd Company, 1953* Centre: *Pontiac, 1950* Ci-dessous: *Plymouth, 1955*

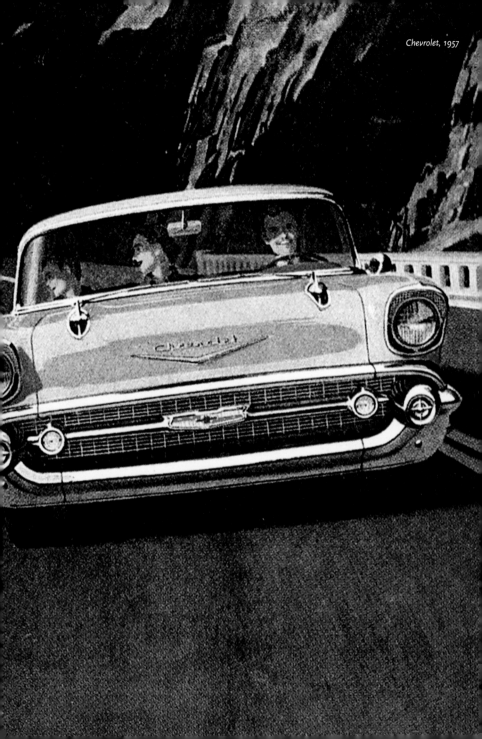

Chevrolet, 1957

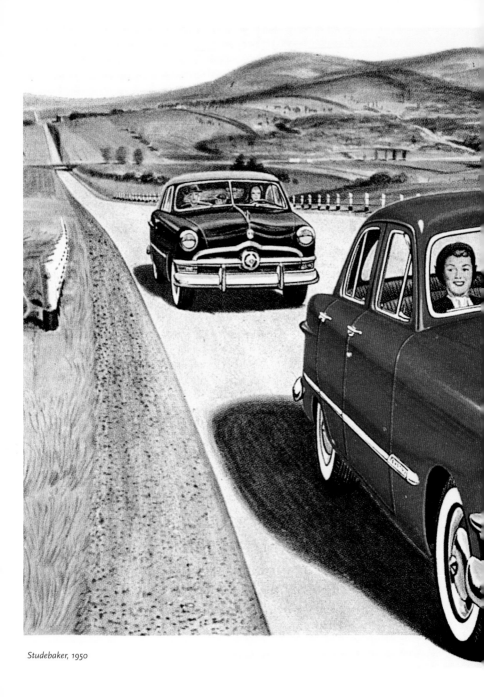

Studebaker, 1950

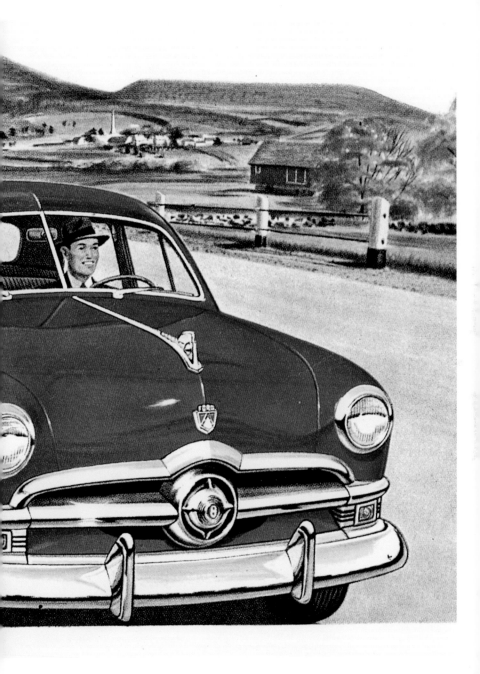

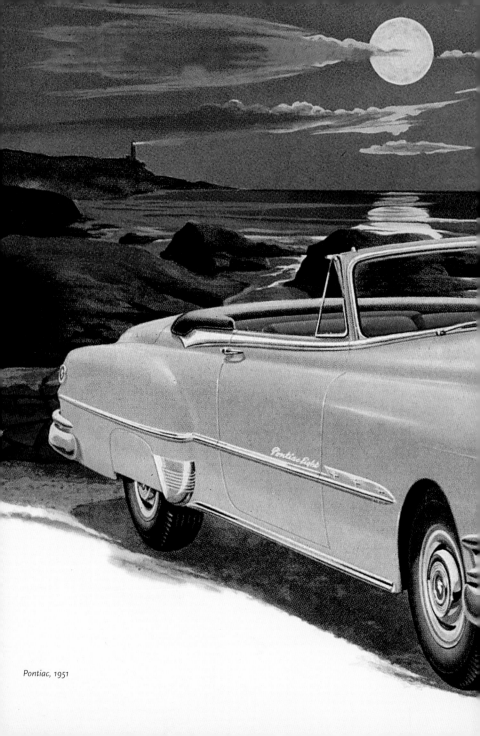

Pontiac, 1951

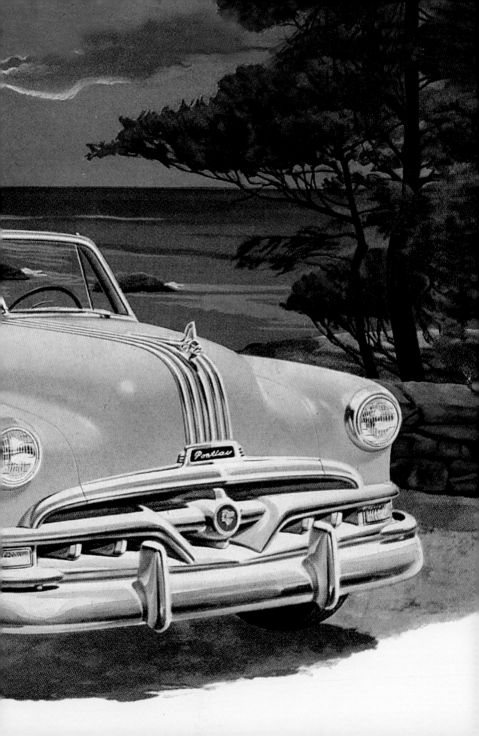

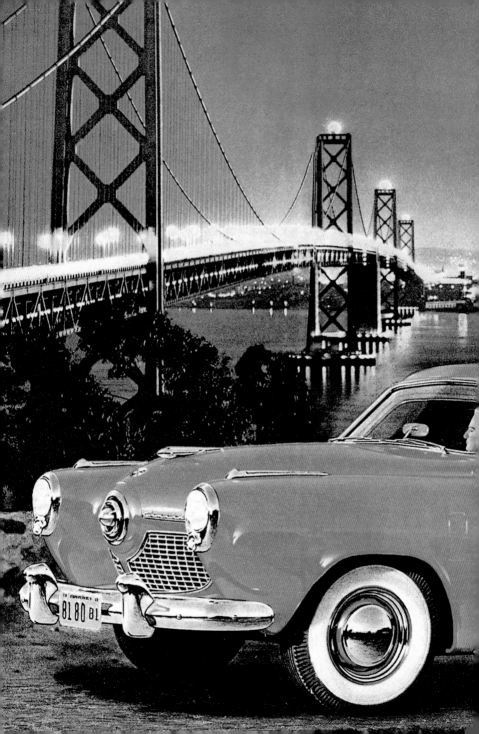

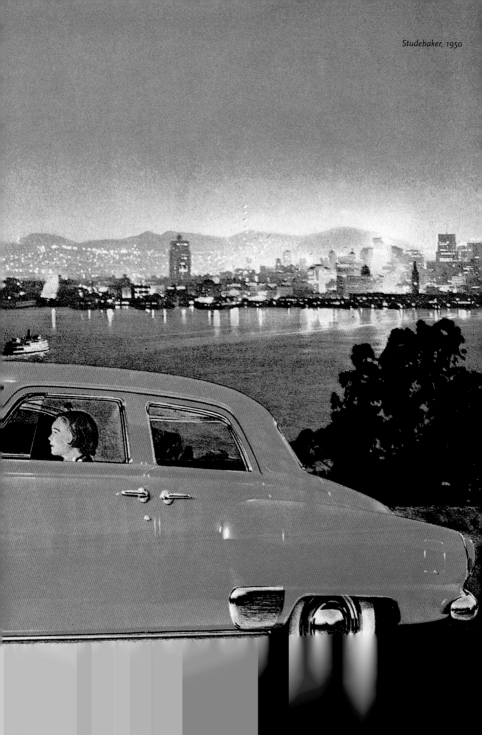

Studebaker, 1950

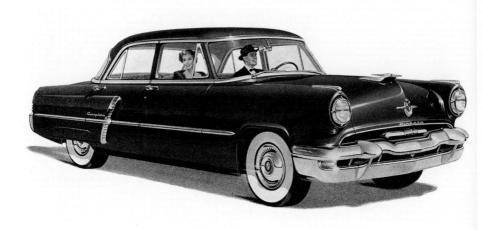

▲*Lincoln, 1952*

▼*Nash, 1950*

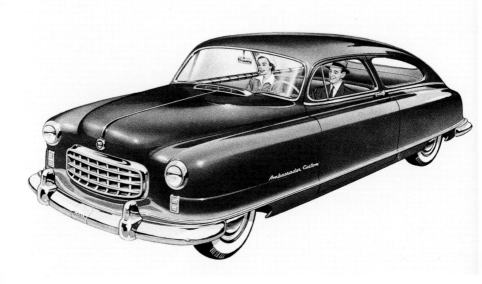

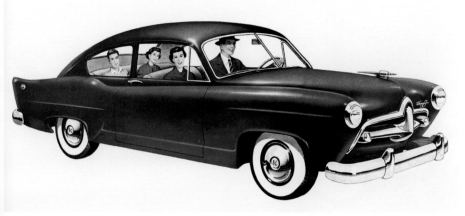

▲Henry J, 1950

▼Mercury, 1950

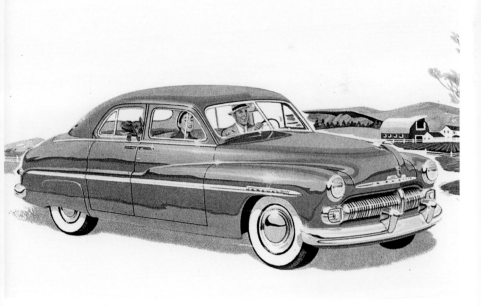

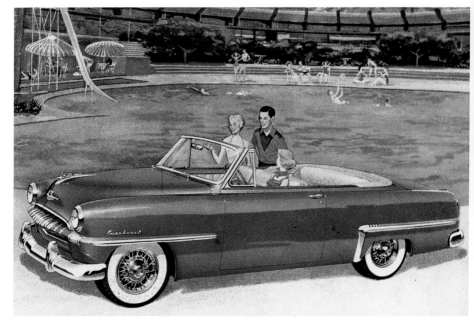

▲Plymouth, 1953

▼Hudson, 1951

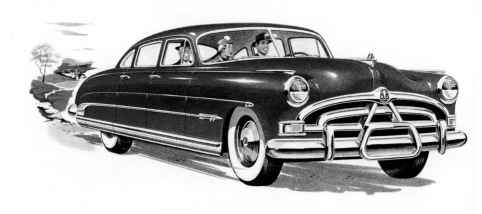

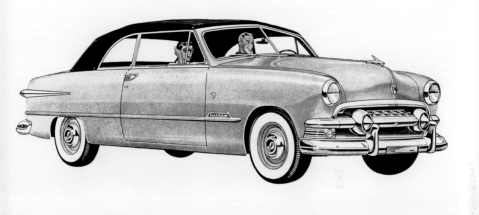

▲ *Ford, 1951*

▼ *Mercury, 1951*

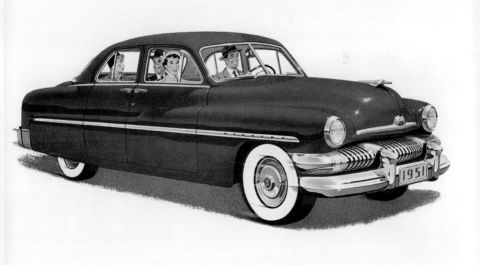

Stretch Out and See

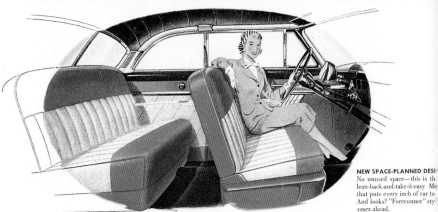

NEW SPACE-PLANNED DESI
No unused space—this is th
lean-back-and-take-it-easy Me
that puts every inch of car to
And looks? "Forerunner" sty
years ahead.

Why It Challenges Them All

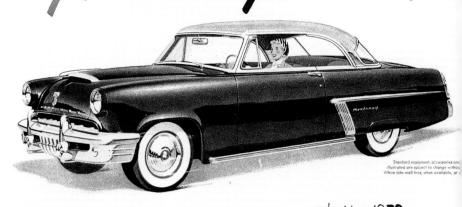

Standard equipment, accessories and
illustrated are subject to change withou
White side-wall tires, when available, at e

NEW SEA-TINT® GLASS reduces heat, glare, and eyestrain. New larger windows permit safety-sure visibility all around. *Every* view proves that Mercury is new—in looks, in power, in extra value.

WE BUILT A NEW CAR and made this challenge: Match Mercury *if you can*. Now we know we've got the sweetest thing on wheels since the ladies began to drive.

For all America is falling in love with a car.

No wonder. It's big and beautiful, inside, outside, and all over. With a host of Future Features—Forerunner styling, Jet-scoop hood, suspension-mounted brake pedal, Interceptor instrument panel, higher horsepower V-8 engine—the new Mercury is the most challenging car that ever came down the *American Road*.

See it, drive it. You'll fall in love, too. And with Mercury's famous economy—*proved* in official tests— this is a love affair you can afford.

MERCURY DIVISION · FORD MOTOR COMPANY

The New 19**52**

MERCURY

WITH MERC-O-MATIC DRIVE

3-WAY CHOICE—Mercury presents three dependable, perform proved drives: silent-ease, standard transmission; thrifty Tou Matic Overdrive,* and Merc-O-Matic,* greatest of all automatic d
*Optional at exe

Ford, 1951

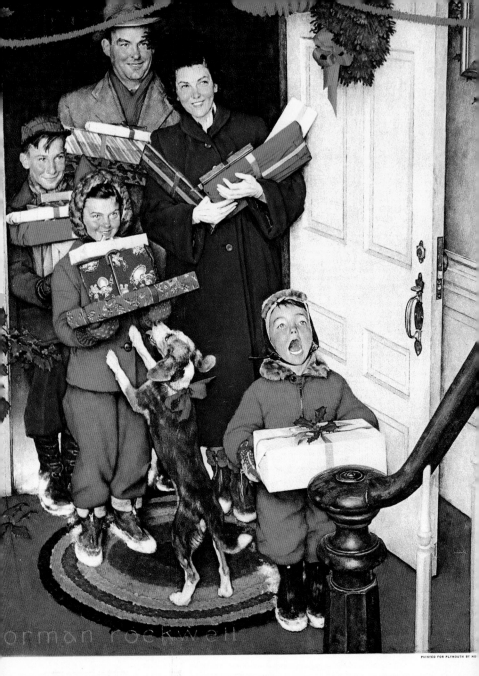

PAINTED FOR PLYMOUTH BY NO

"*Merry Christmas, Grandma...we came in our new* PLYMOUTH*!*

Plymouth, 1950

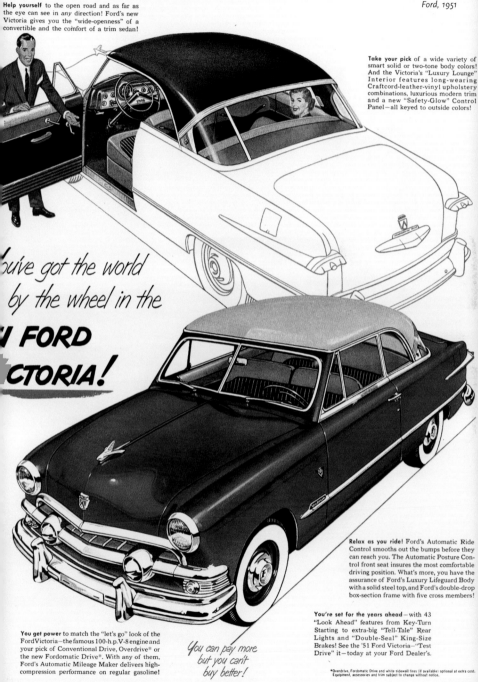

NOW—a fine car that meets every test of modern living

Lincoln for 1952

IN TWO INCOMPARABLE SERIES —
THE *Cosmopolitan* — THE *Capri*

NEW GLASS-WALL VISIBILITY—There's a new way of life in Amer reflected in today's glass walled rooms for modern living. Lincoln surrounds you with glass—3271 square inches. With chair-high seat down-sweep hood, even the daintiest woman driver can see the front fender—see the road in front and way ahead. Every line has a re

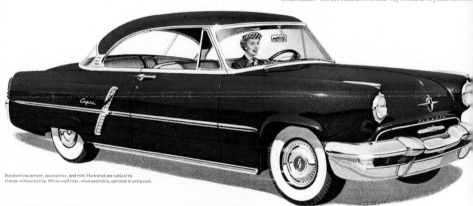

Standard equipment, accessories, and trim illustrated are subject to change without notice. White-wall tires, when available, optional at extra cost.

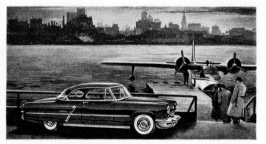

NEW FLIGHT-LIKE POWER—There's ready-to-fly excitement in Lincoln's completely new, overhead-valve, high-compression, V-8 engine—premium product of the company that has built more V-8's than all other makers combined. With HYDRA-MATIC Transmission (as standard equipment), and new ball-joint front suspension (first on a standard U.S. car), steering and handling are astonishingly effortless.

NEW VERSATILE SMARTNESS—This is beauty with purpose. Righ trip or town, a business car, a family car—with more leg room, m head room, almost 30 cu. ft. in the luggage compartment. Yet Lin is smartly sized to thread through traffic, park easily, fit your gar *The one fine car deliberately designed for modern living.*

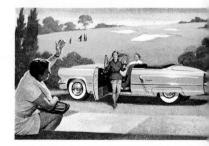

LINCOLN DIVISION—FORD MOTOR COMPANY

Lincoln, 1952

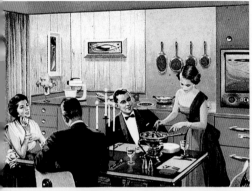

RT YET CASUAL—LIKE THE MODERN HOSTESS. Clean-lined, without gingerbread, new Lincoln is proof that a fine car can be as handsomely functional as the -day homes—and new-day living. Inside, you find superb fittings—and the seats high, the hood is low; you can *see* the road directly ahead, you can *see* d all around through 3,721 square inches of glass (sea-tint glass available).

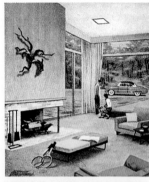

VERSATILE AS A LIVING ROOM DESIGNED FOR LIVING. Lincoln is luxurious yet maneuverable, beautiful yet *powerful*. New V-8 engine, with overhead valves, 7.5 to 1 compression ratio— plus new, improved dual range HYDRA-MATIC Transmission. And, with new ball-joint front wheel suspension, first on a U.S. production car, handling becomes astonishingly easy.

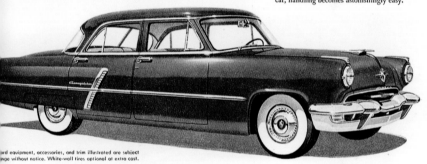

ard equipment, accessories, and trim illustrated are subject
nge without notice. White-wall tires optional at extra cost.

IN TWO INCOMPARABLE SERIES—
THE COSMOPOLITAN—THE CAPRI

Now— LINCOLN

makes your driving as modern as your living

It is completely new. It is almost incredibly new. But more than this—it is an entirely new *approach* to fine automobiles, designed for those whose concept of luxury motoring does not include the common, the ponderous, or the unwieldy.

Lincoln for 1952 is for those who ask their car to match their new perspective on living. Though it may well be the most luxurious automobile on the *American Road*, it is magnificently *functional*.

There is a reason for every dimension. There is a purpose behind each line. The new Lincoln is spirited, compact, and surpassingly efficient.

There is only one way to know this new kind of motoring—this fine car that is like a feather in traffic, an arrow on the road. That way is to try it and to drive it. See the new Lincoln Cosmopolitan and Capri at your dealer's showroom. Lincoln—*the one fine car deliberately designed for modern living.*
LINCOLN DIVISION—FORD MOTOR COMPANY

Lincoln, 1952

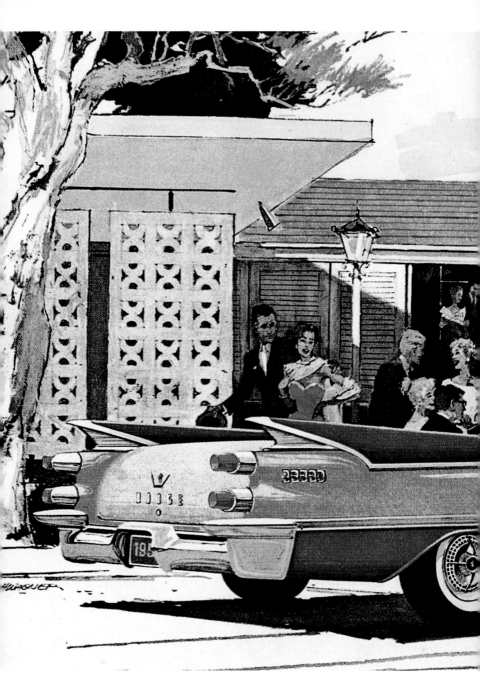

Dodge, 1958

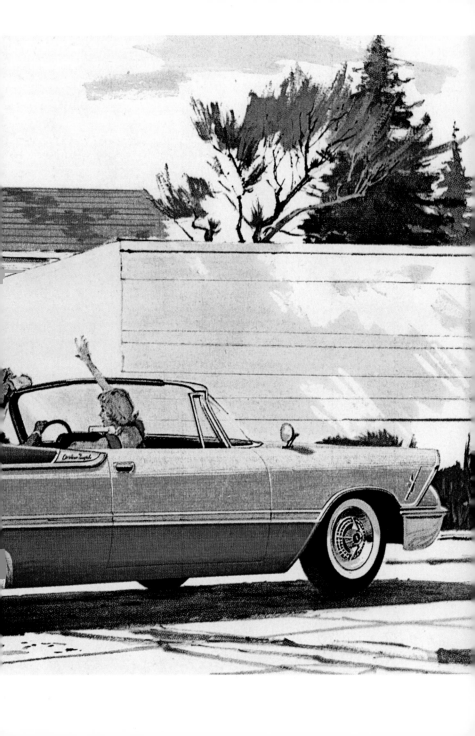

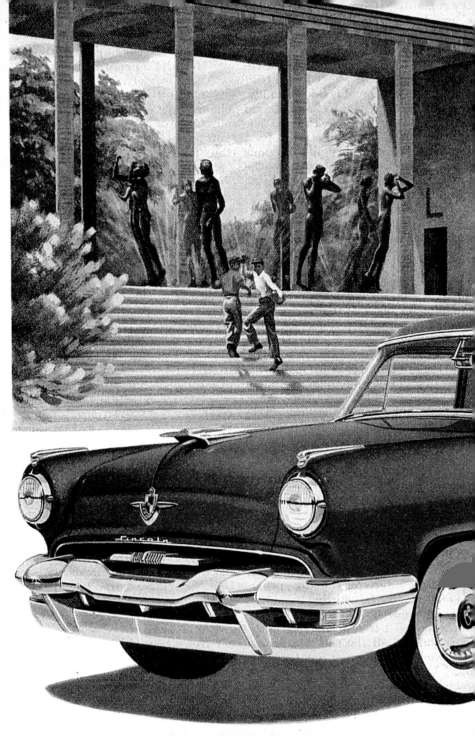

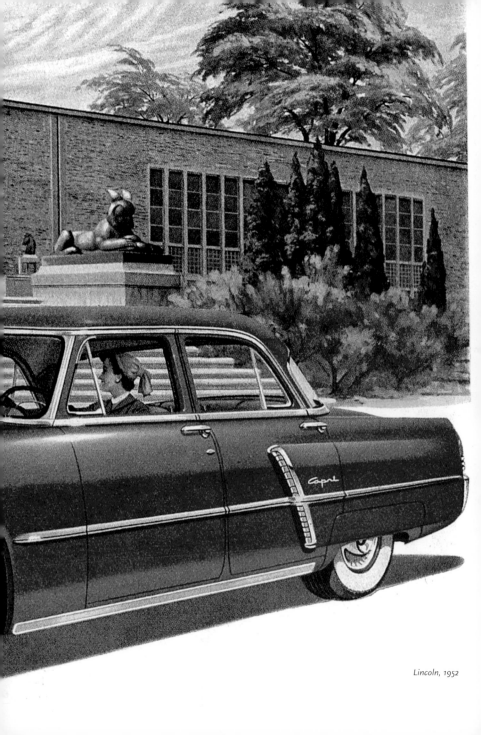

Lincoln, 1952

These keys unlock GREATER VALUE

Here are the five new cars General Motors offers you for '52.

Each has a famous name of its own: Chevrolet, Pontiac, Oldsmobile, Buick, Cadillac.

Each has its own personality in styling, appointments, features, power.

But all enjoy an advantage which stems from the research into better ways to do things—the testing of everything from the integrity of metal to the soundness of design — the broad knowledge of engineering and manufacturing methods which General Motors provides.

The results, as you will discover, are comfort, convenience, performance unknown a few years ago.

Each year witnesses new advances—and we believe you will find these newest cars, now readied for the market, the finest we have built thus far.

We invite you to see them now at your local GM dealer's — and you will know why "your key to greater value" appears on the key of every car.

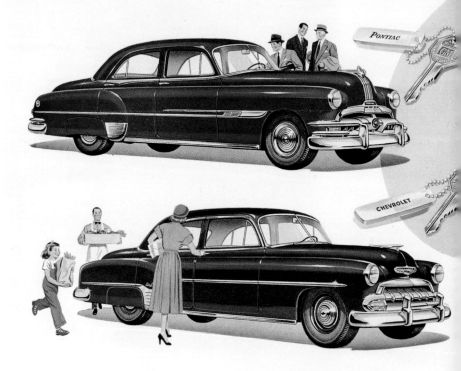

"MORE AND BETTER THINGS FOR MORE PEOPLE"

GENERAL MOTORS

General Motors, 1952

34

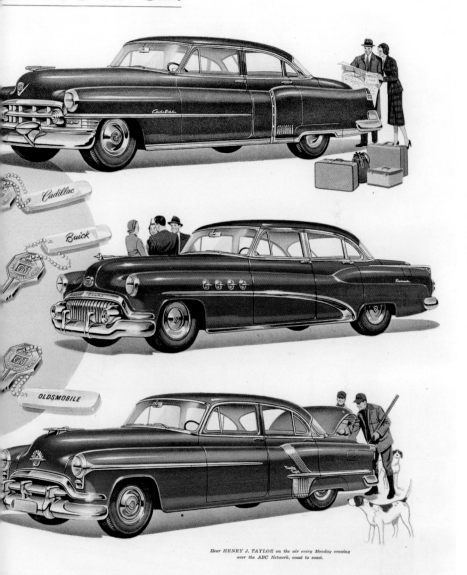

Hear HENRY J. TAYLOR on the air every Monday evening over the ABC Network, coast to coast.

Your Key to Greater Value — The Key to a General Motors Car

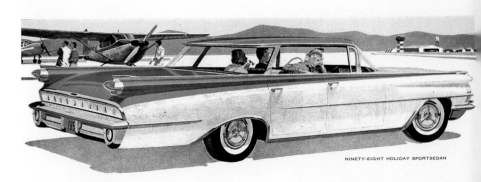

NINETY-EIGHT HOLIDAY SPORTSEDAN

Every 1959 Oldsmobile has the smart new "Linear Look"—trim, light, wide-open, spacious! Inside and out it's aglow with bright ideas—safer brakes, improved visibility, smoother ride, more luggage room. Yes, and a brand-new Rocket Engine, too! An engine that is incredibly smooth, the most efficient Rocket yet. Think a moment. Isn't it time to step up to an Olds—*acknowledged leader in the medium price class!* Talk it over with your local quality dealer.

OLDSMOBILE DIVISION,
GENERAL MOTORS CORPORATION

OLDSMOBILE FOR '59

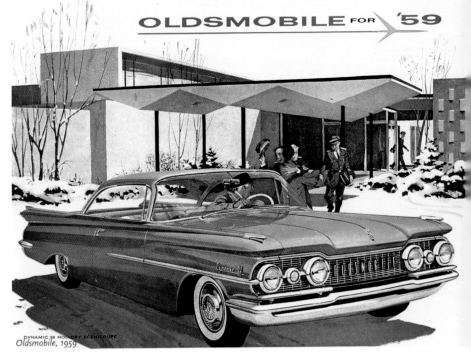

DYNAMIC 88 HOLIDAY SCENICOUPE

Oldsmobile, 1959

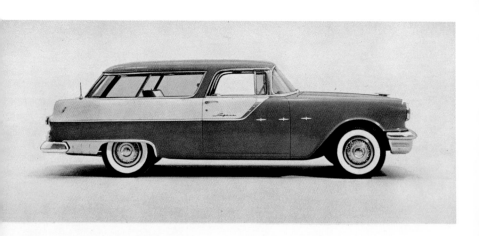

Pontiac creates an entirely new type of car

combining Catalina smartness

and station wagon utility

This completely new Star Chief from the originator of hardtop styling is easily the most versatile of motor cars. Appointed with traditional Catalina luxury, yet retaining all the spacious practicality of a station wagon, the Safari will serve you equally well as a smart town car, a wondrously comfortable touring companion, or a hard-working carrier. It is powered, of course, by the sensational Strato-Streak V-8 for performance as distinctive as its beauty. See it today—the price will delight you as much as the car!

THE PONTIAC *Safari*

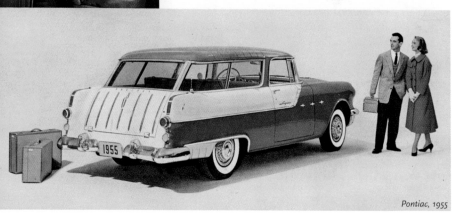

Pontiac, 1955

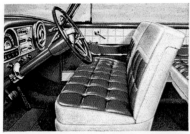

Hand-buffed leather in coral and ivory, deep-pile matching carpet and color-keyed instrument panel and wheel typify the luxurious new interiors of the '54 Custom Catalinas.

Dollar for Dollar You Can't Beat a

PONTIAC

A GENERAL MOTORS MASTERPIECE

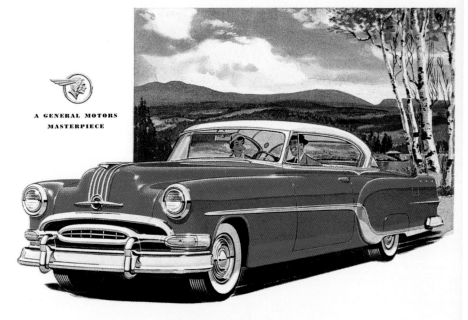

America's First Low Cost Luxury Car

You are looking at the new wonder of the motoring world, the completely new Star Chief Pontiac. And what makes this car such a wonder is its unsurpassed combination of superb quality and low price. *There has never been anything like it.* For here is the biggest, richest and most powerful Pontiac ever built—qualified by length, luxury, styling and per-

formance to rank with the very finest cars. Yet the proud and beautiful Star Chief can adorn your driveway no matter how carefully you budget new car expenditures. It is still comfortably within the price range just above the lowest!

And America's first low cost luxury car is only half the great news from Pontiac. For 1954, the Chieftain, General Motors

lowest priced eight, is also mightier than ever and far more beautiful inside and out—again the dominant dollar for dollar value at its very modest cost.

Check Pontiac's remarkable score for '54. See, drive and price these distinguished new Silver Streak Pontiacs. Prove to your pleasure and profit that never before have quality and low cost been so beautifully combined.

You compress time.... distance

- in effortless ease
with the first
complete driver control!

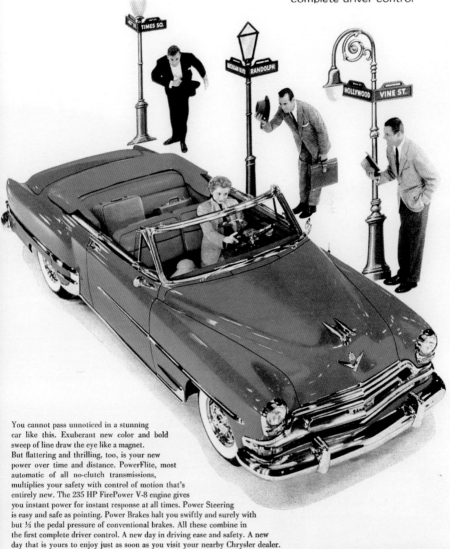

You cannot pass unnoticed in a stunning
car like this. Exuberant new color and bold
sweep of line draw the eye like a magnet.
But flattering and thrilling, too, is your new
power over time and distance. PowerFlite, most
automatic of all no-clutch transmissions,
multiplies your safety with control of motion that's
entirely new. The 235 HP FirePower V-8 engine gives
you instant power for instant response at all times. Power Steering
is easy and safe as pointing. Power Brakes halt you swiftly and surely with
but ⅓ the pedal pressure of conventional brakes. All these combine in
the first complete driver control. A new day in driving ease and safety. A new
day that is yours to enjoy just as soon as you visit your nearby Chrysler dealer.

The Power *and look* of Leadership is yours in a **BEAUTIFUL CHRYSLER**

Plymouth, 1956

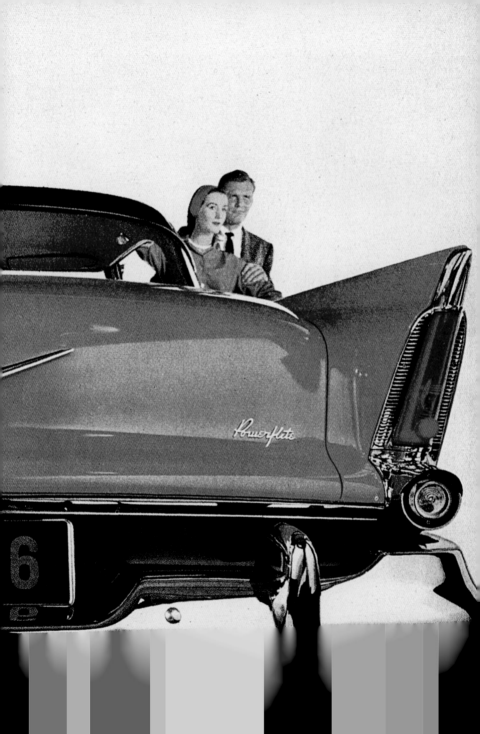

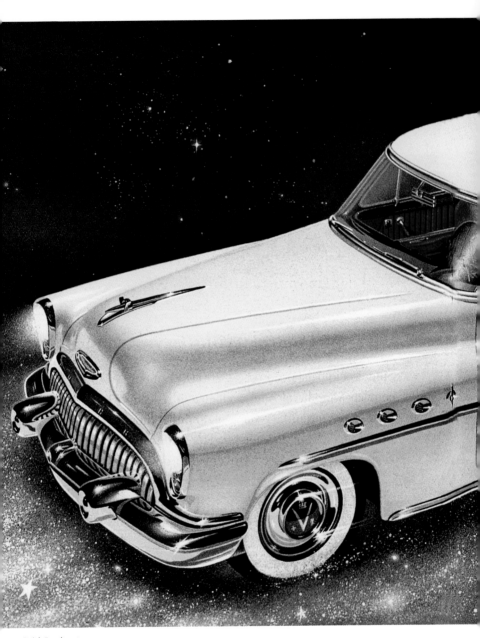

Buick Roadmaster, 1953

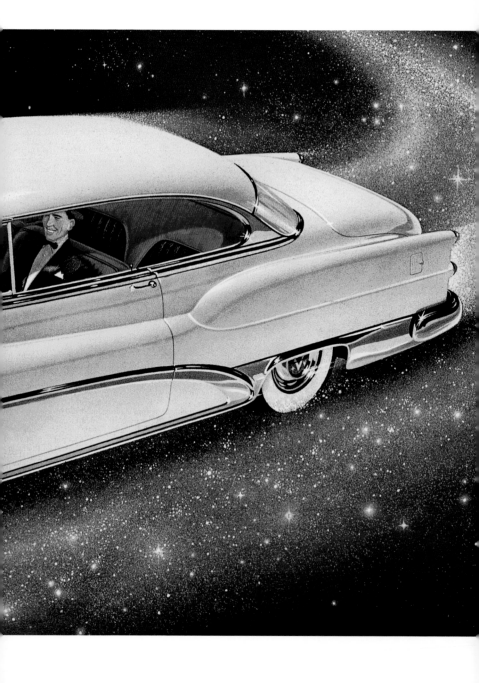

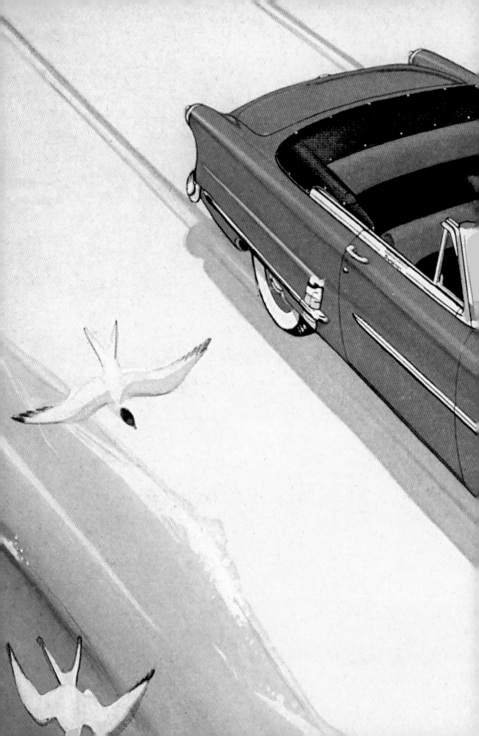

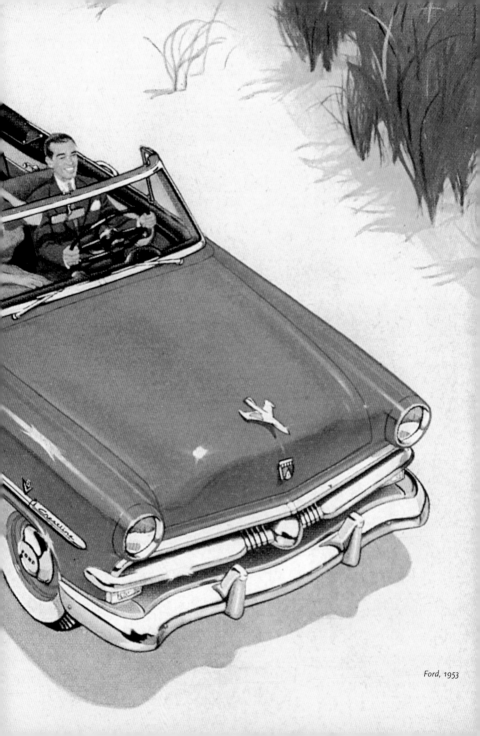

Ford, 1953

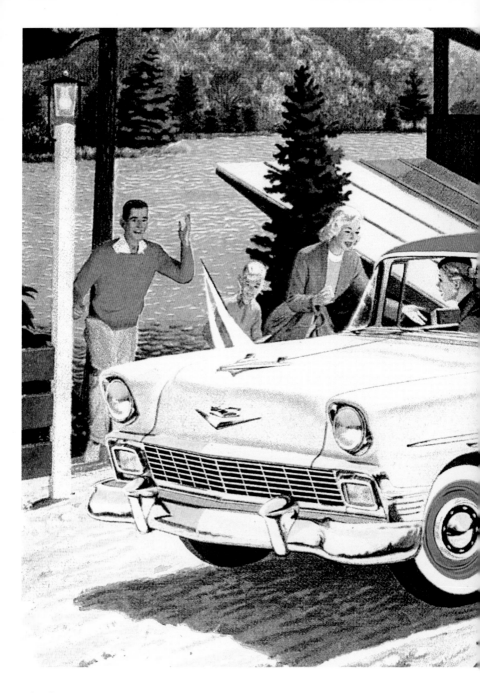

Chevrolet, 1956

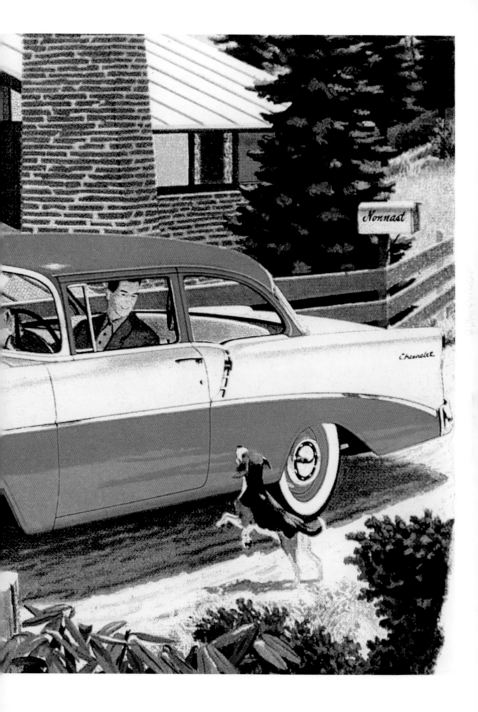

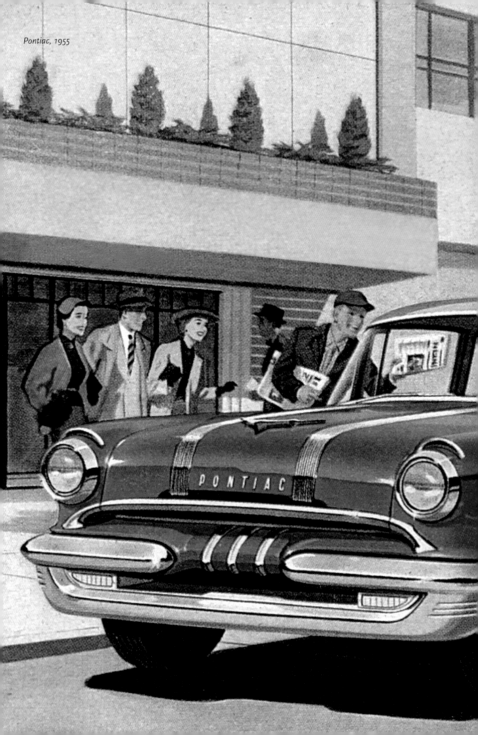

Pontiac, 1955

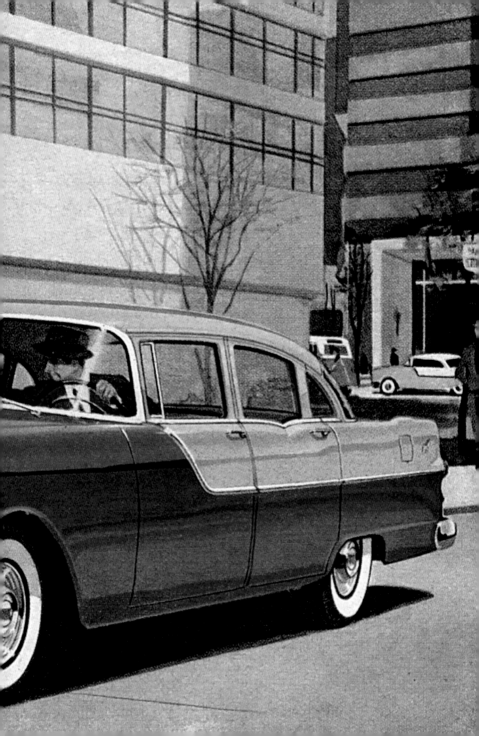

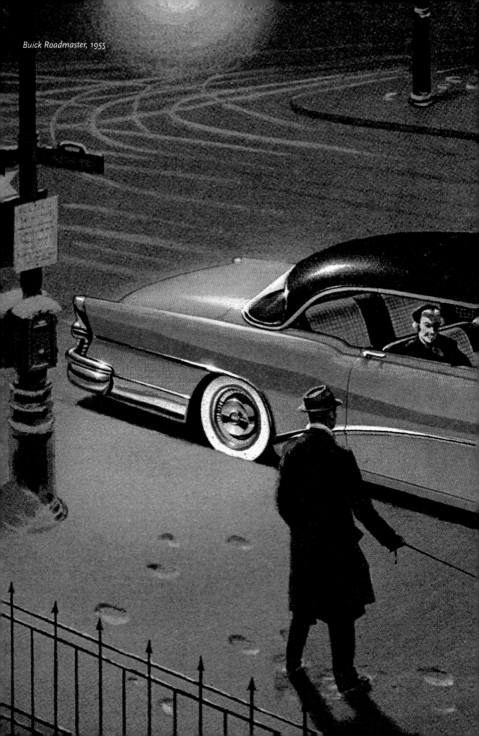

Buick Roadmaster, 1955

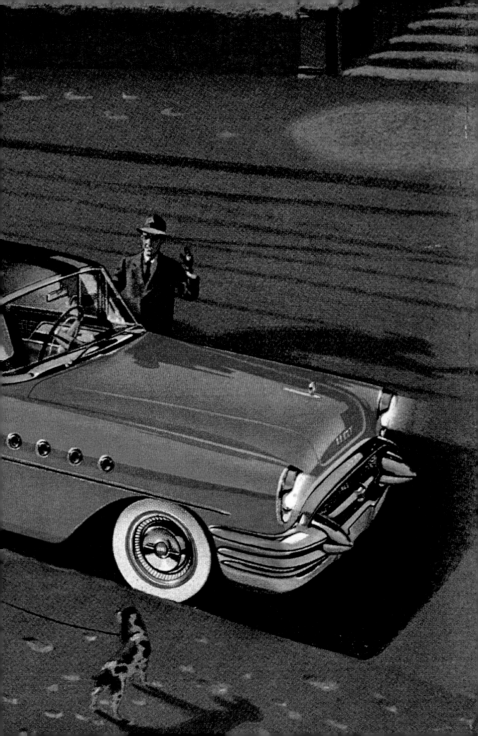

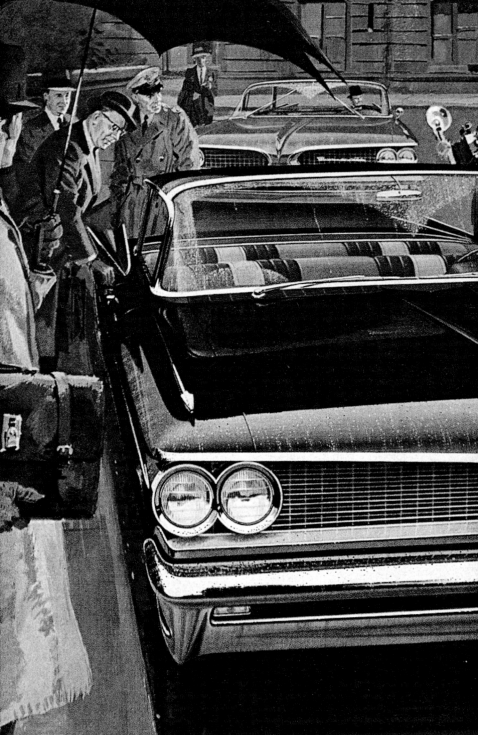

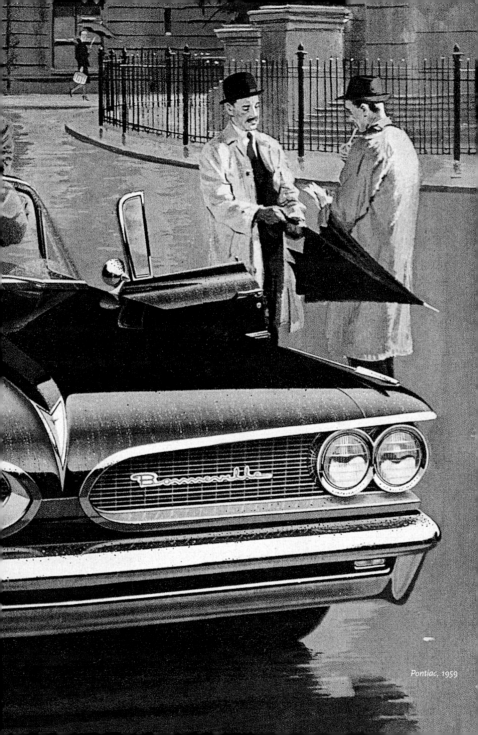

Pontiac, 1959

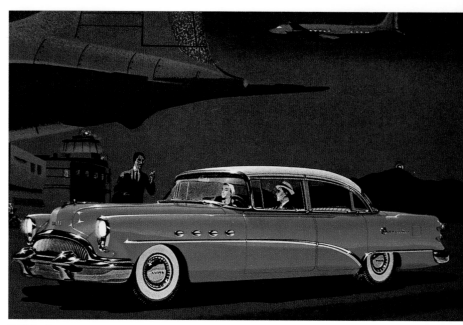

Buick Roadmaster, 1954

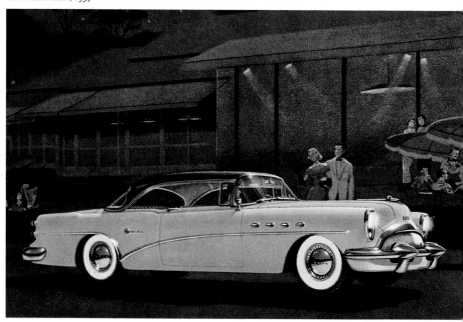

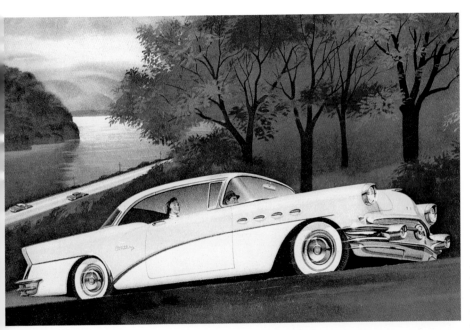

Buick, 1956

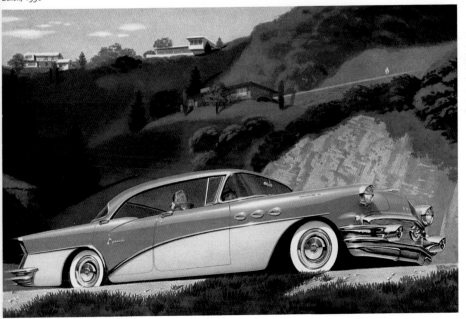

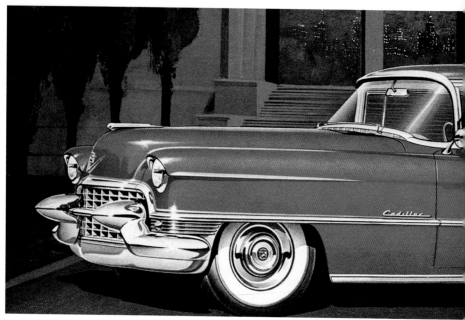

▲Cadillac, 1955

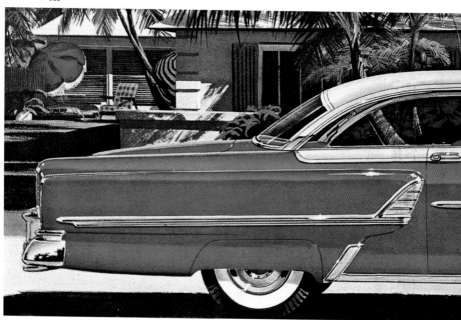

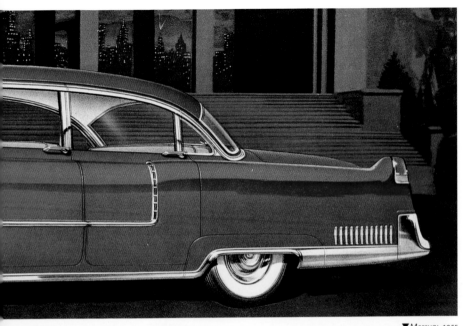

▼ *Mercury, 1955*

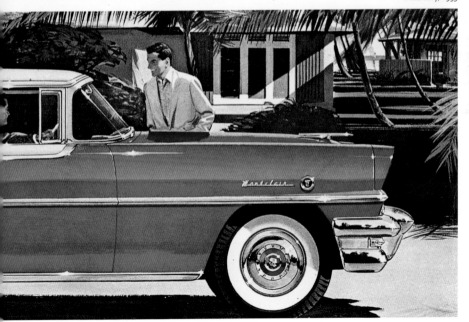

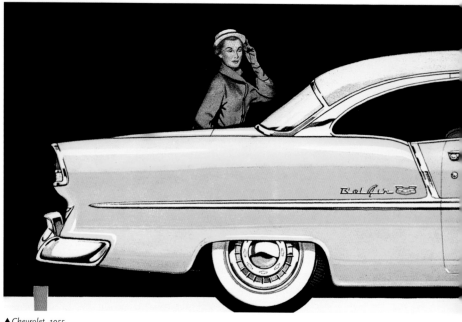

▲Chevrolet, 1955

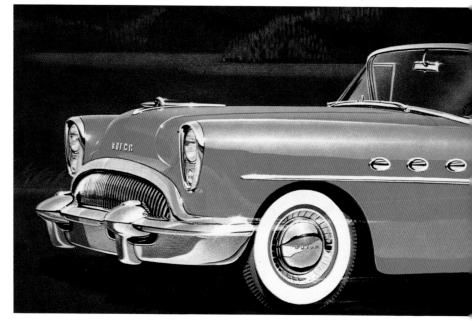

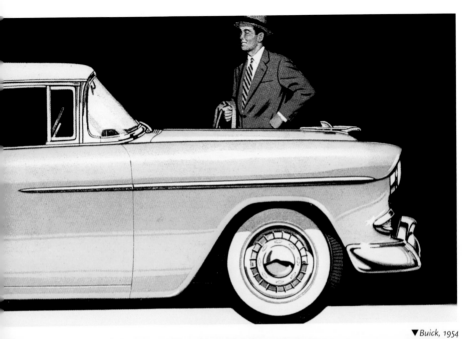

▼ *Buick, 1954*

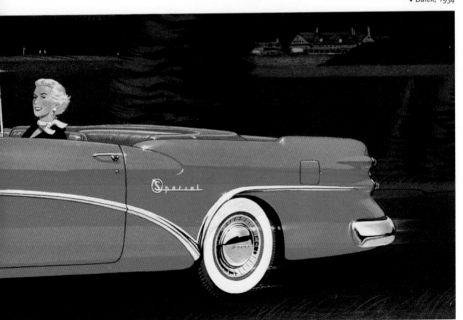

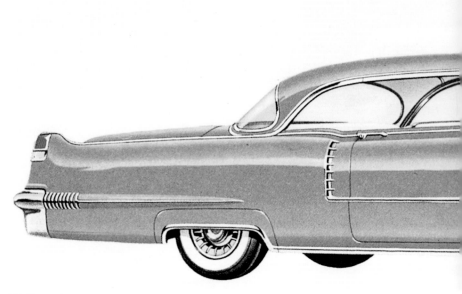

▲Cadillac, 1956

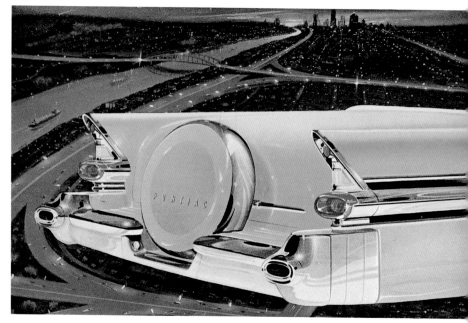

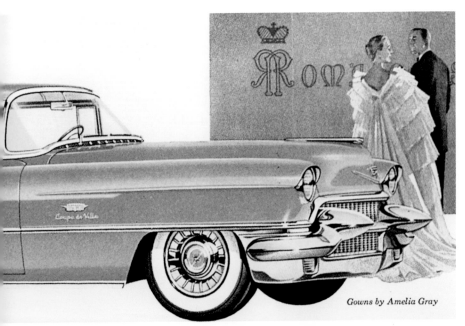

Gowns by Amelia Gray

▼*Pontiac, 1958*

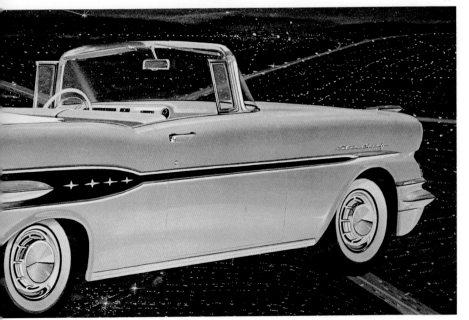

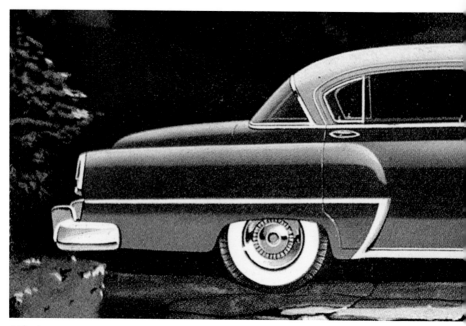

▲Chrysler, 1952

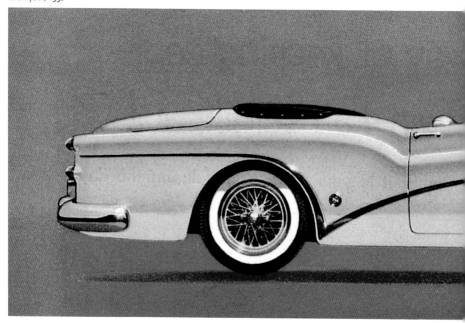

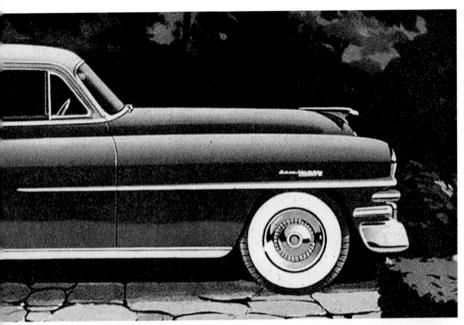

▼ *Buick, 1953*

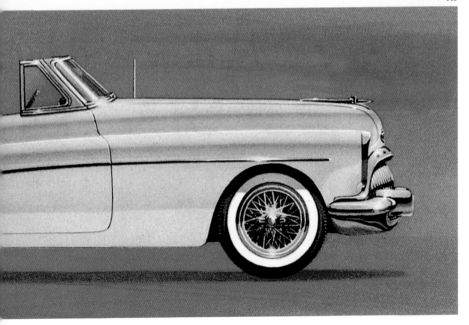

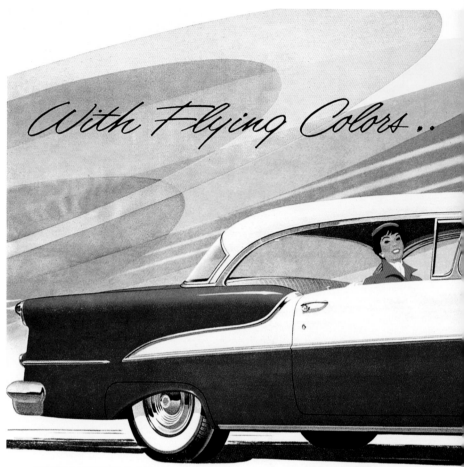

With Flying Colors...

1955 Oldsmobile Super "88" Holiday Coupé. A General Motors Value.

OLDSMOBILE 88

ROCKETS INTO 1955!

Oldsmobile, 1955

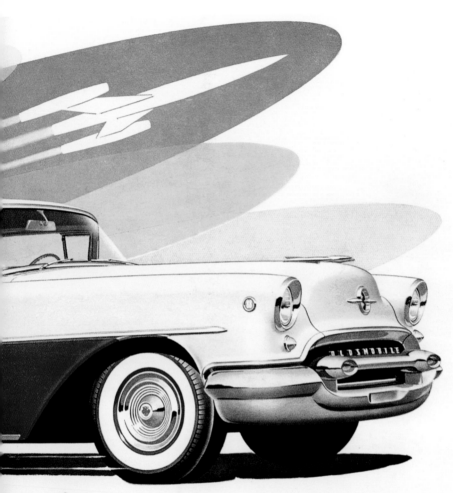

Flashing into the future with flying colors . . . *Oldsmobile for '55!* . . . *more spectacular, more colorful, more powerful* than ever! In three exciting series (Ninety-Eight, Super "88", "88"), every one of them new, all-around-new, *all the way through!* And Oldsmobile's owner-proved "Rocket"—the engine that blazed the way into the Power Era—is all-new, too! New 202 horsepower, new higher torque, new higher compression ratio—new combustion chambers! Every new Oldsmobile has that commanding new "Go-Ahead" look—bold, sweeping front-end design—dramatic new "flying color" patterns—dazzling new styling from front to rear—the newest *new ideas on wheels!* More than ever, Oldsmobile is out ahead to *stay ahead!* See your dealer now . . . see these magnificent new "Rocket" Oldsmobiles for 1955!

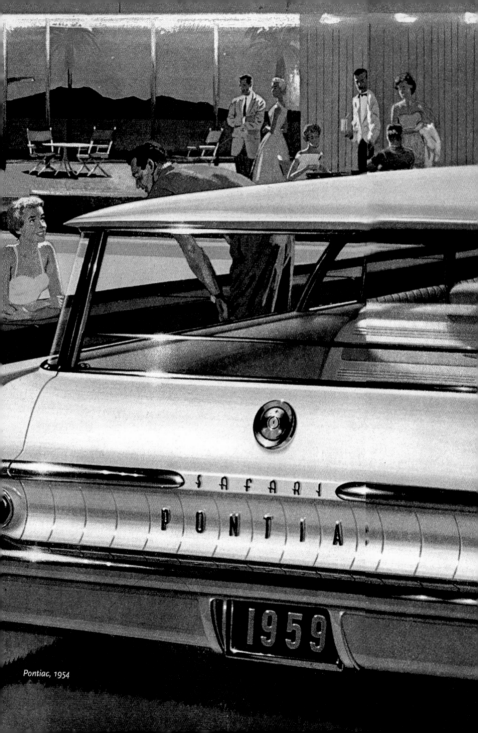

Pontiac, 1954

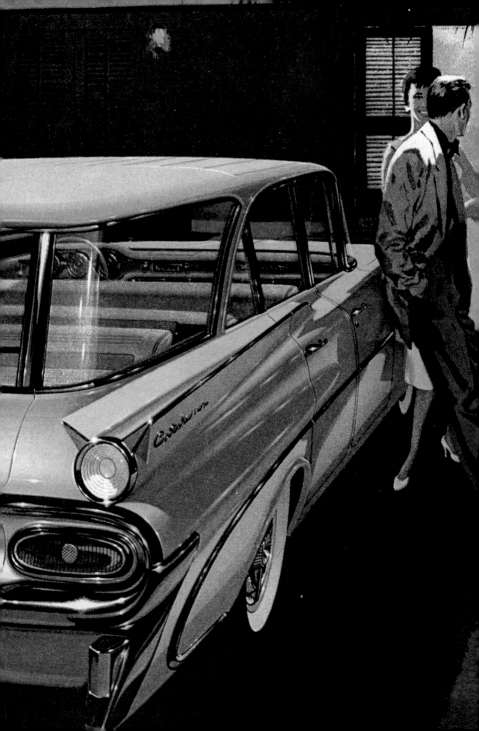

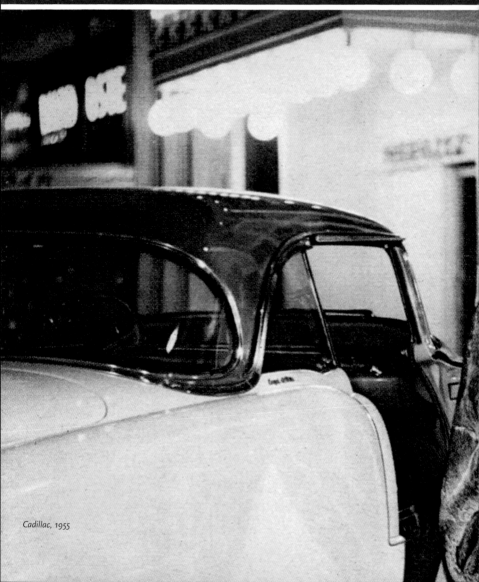

Cadillac, 1955

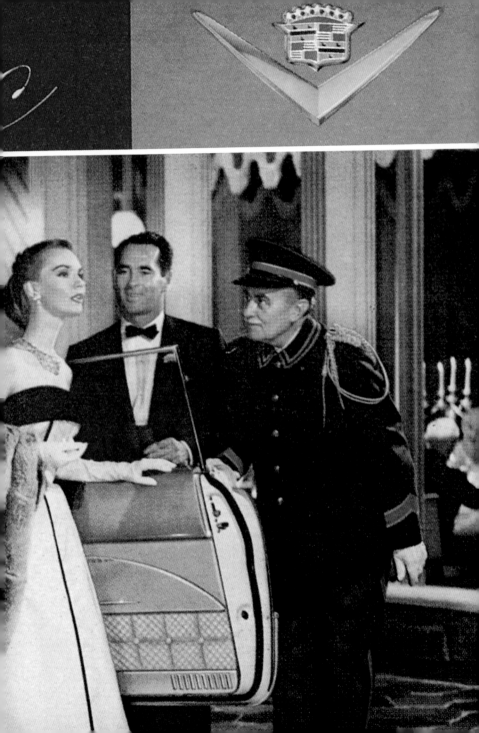

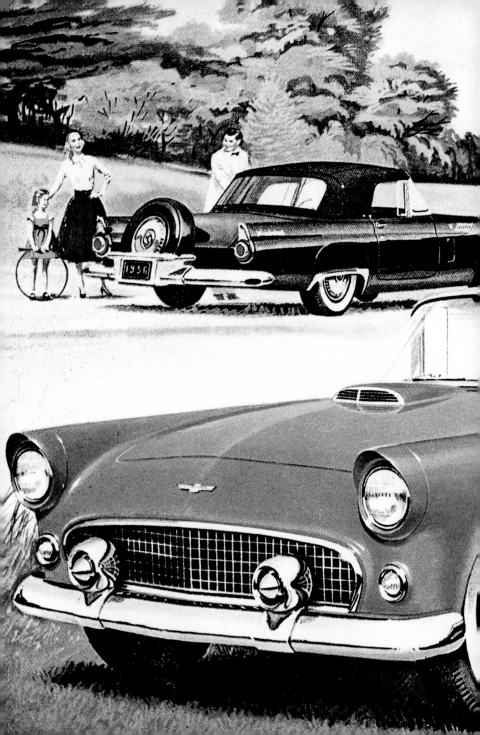

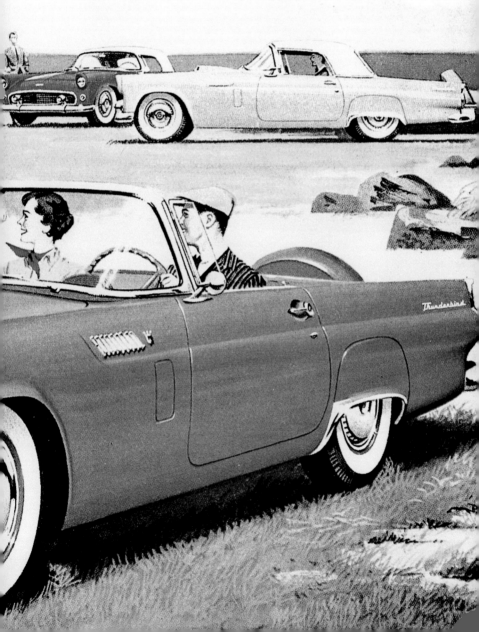

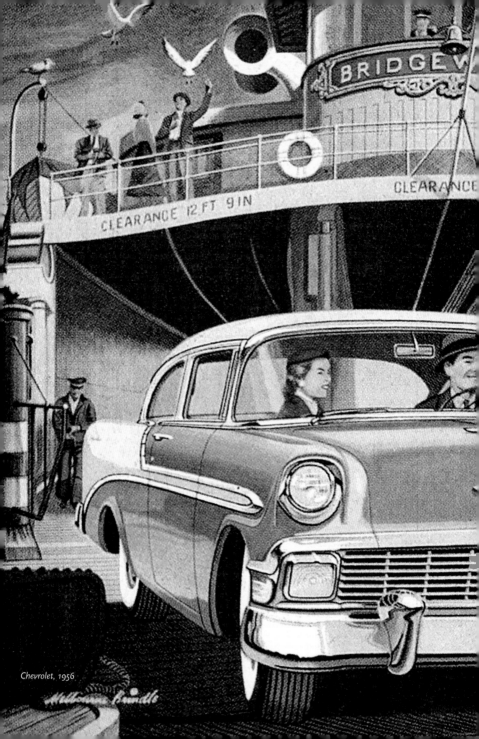

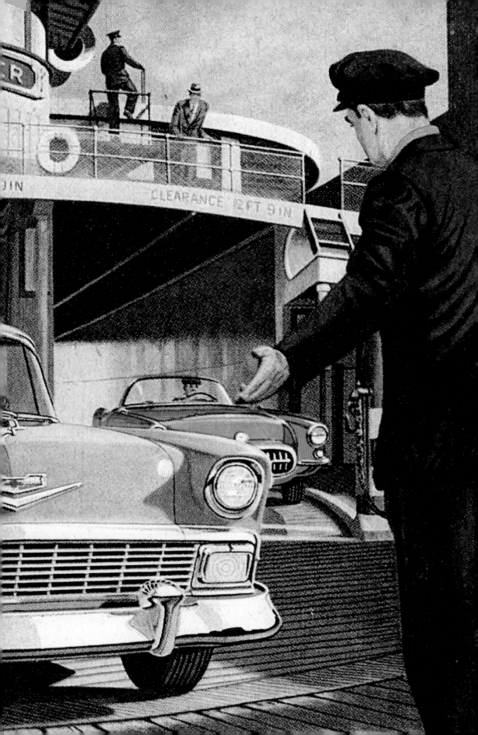

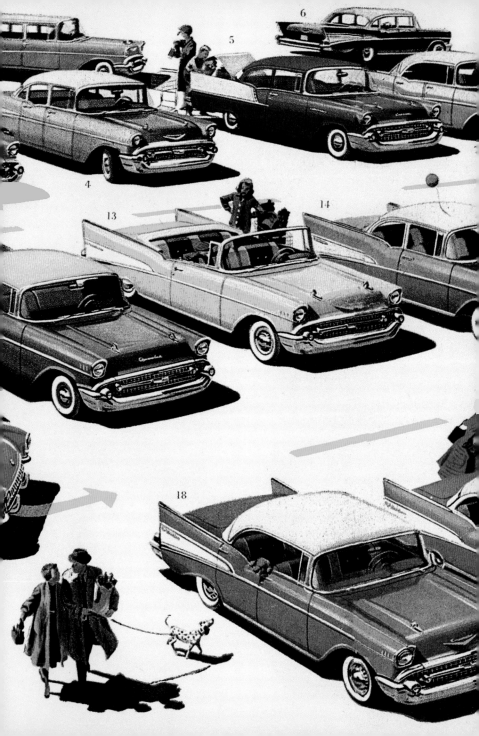

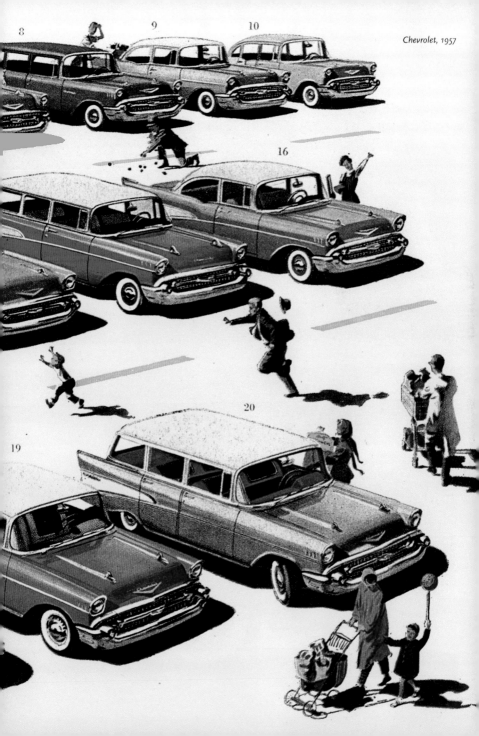

Chevrolet, 1957

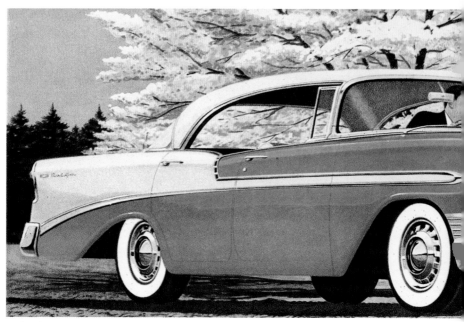

▲ *Chevrolet, 1956*

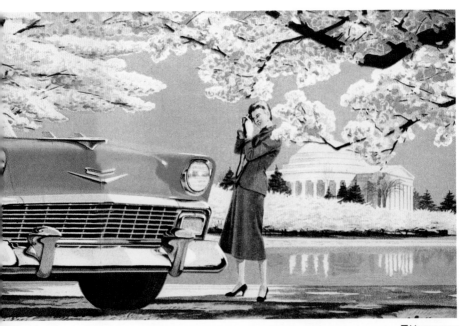

▼ *Mercury, 1955*

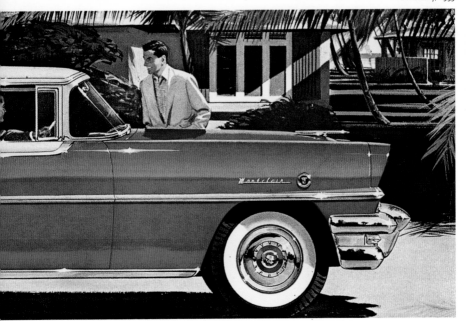

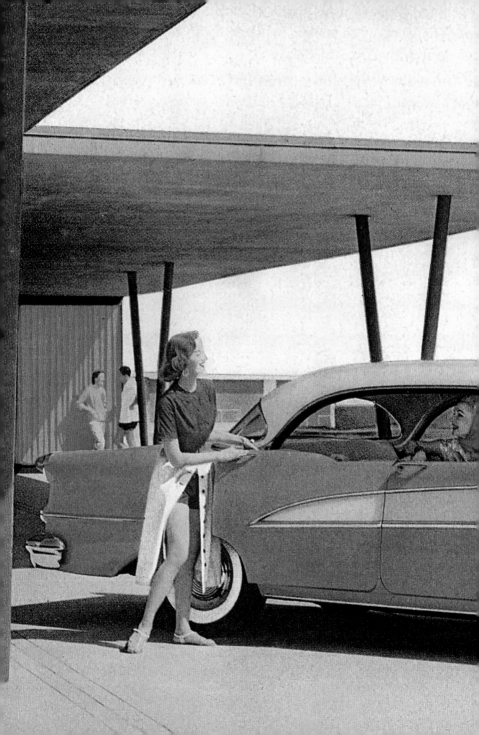

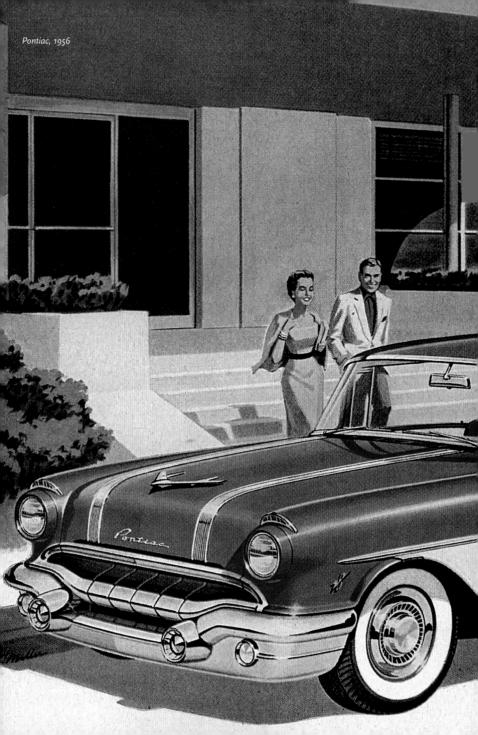

Pontiac, 1956

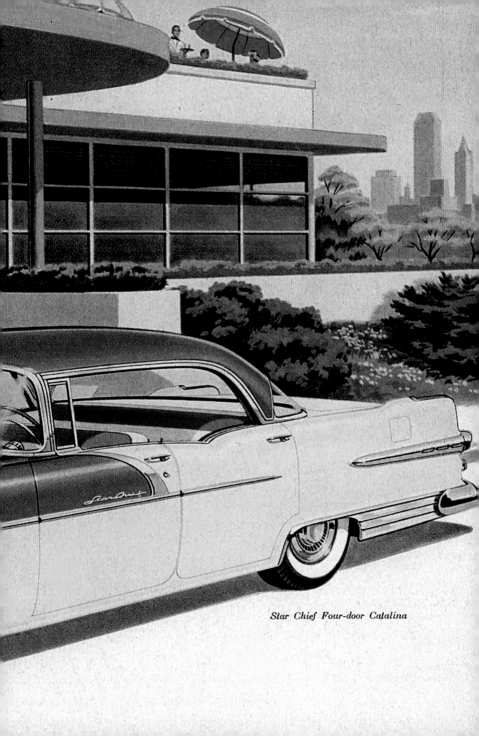

Star Chief Four-door Catalina

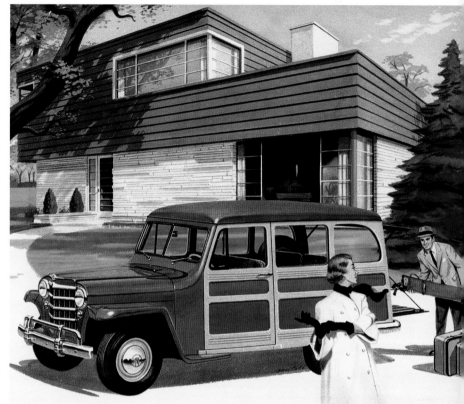

"*We needn't stop for gas*
. . . I filled it last week"

WILLYS *makes sense*

— IN ECONOMY — IN EASE OF DRIVING — IN COMFORT

Goes a long, long way on a gallon

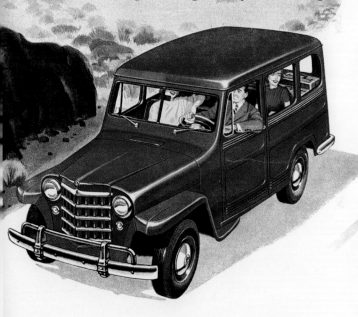

WILLYS *makes sense*

-IN DESIGN -IN ECONOMY -IN USEFULNESS

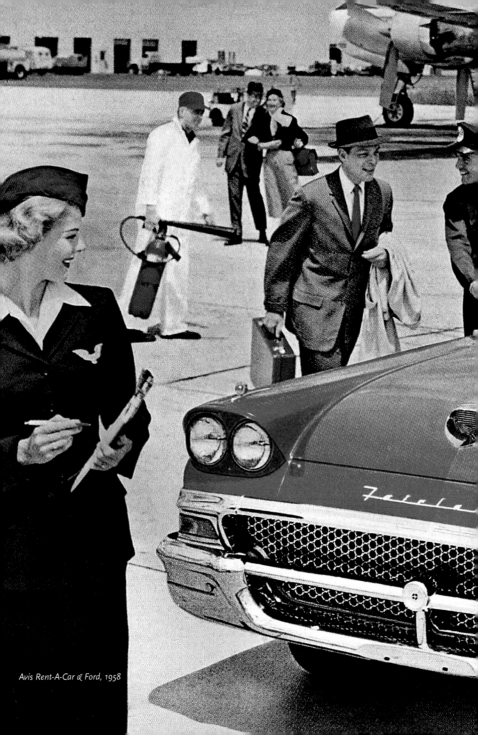

Avis Rent-A-Car & Ford, 1958

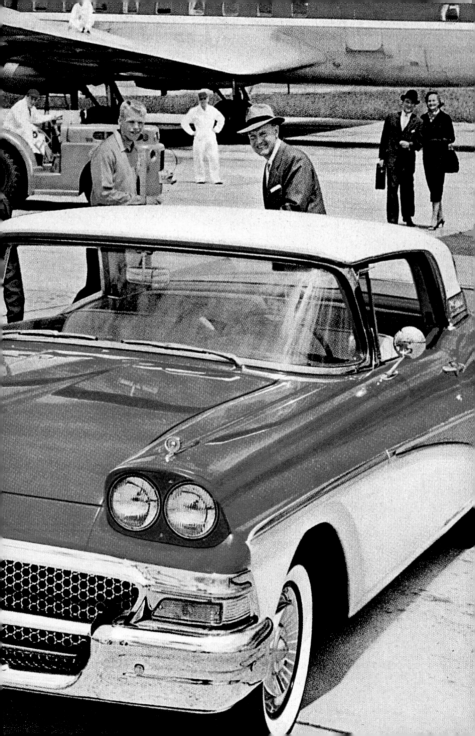

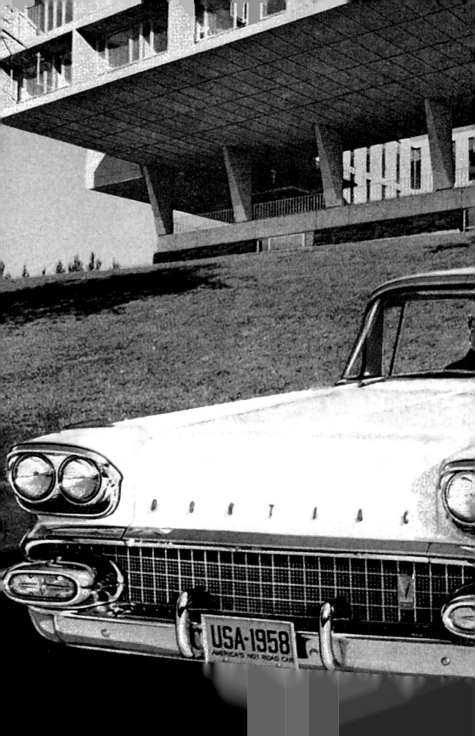

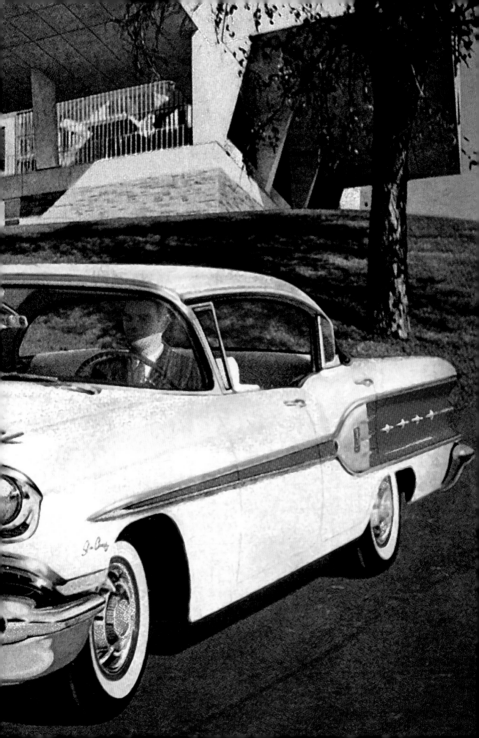

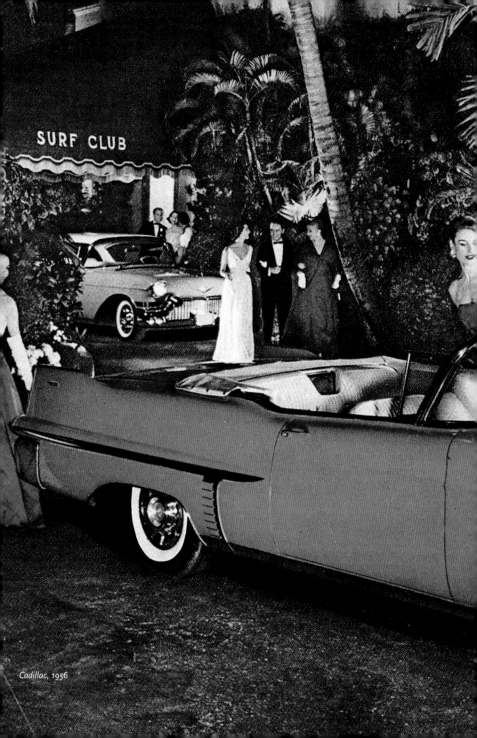

SURF CLUB

Cadillac, 1956

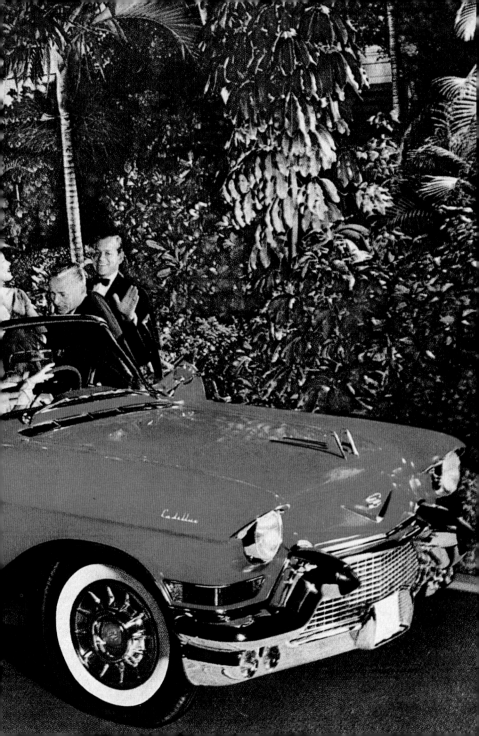

The car conceived and create
to change your ideas of luxury motorin

This is sweeping line and commanding length. This is unusual richness of interior
cushioning and appointment. This is uncompromising precision. This is the LIMITED.
It is the car we conceived and created to outmode the present measure of fine cars.
It is the car you will drive with a new sense of magnificence that grows out of its
performance, its comfort, its excellence of construction. Your Buick dealer cordially invites
you to see the distinguished LIMITED—and to take a personal demonstration behind its
wheel. See him for an appointment.

PROUDLY PRESENTED. PROUDLY POSSESSED *The*

LIMITED

by Buick

We deliberately designed it

Beyond a doubt, this newest of fine cars goes well beyond the familiar concepts of luxury and performance. Indeed, that was our goal in creating the LIMITED. Thus, its interior presents a degree of elegance and comfort that sets a new level of magnificence. Its performance exceeds existing standards—to the point of providing a wholly new experience in ease of handling and serenity of ride. Even in the matter of its extra length, the LIMITED goes beyond the call of familiar dimensions. You will find this superbly crafted automobile a most satisfying possession —and your Buick dealer will be understandably proud to introduce you to it.

BUICK *Division of* GENERAL MOTORS

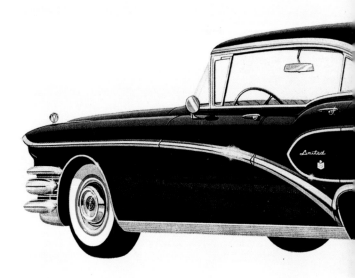

se the world's finest automobile

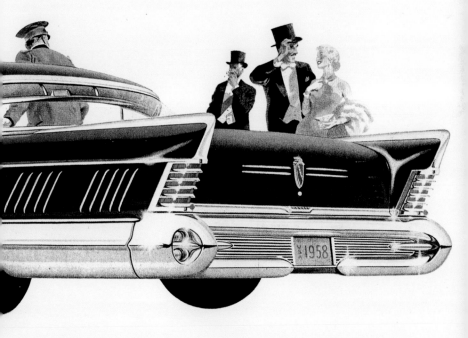

Cadillac, 1956

The Sixty Special

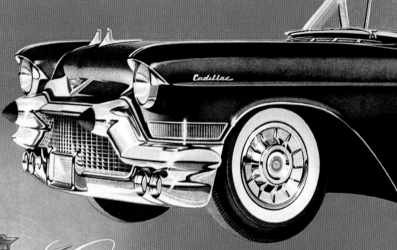

Cadillac for 1957...brillian

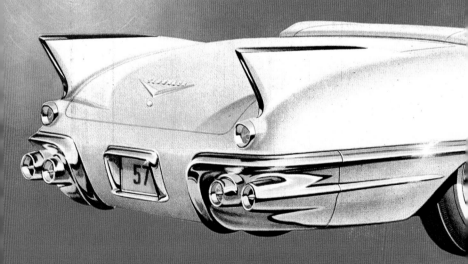

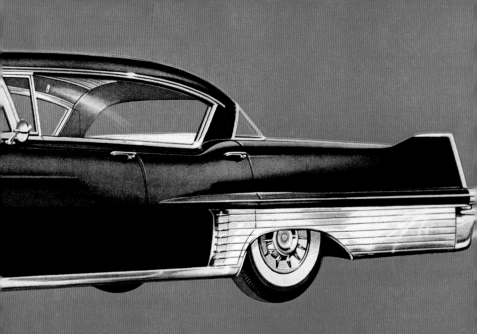

...w in beauty, brilliantly new in performance!

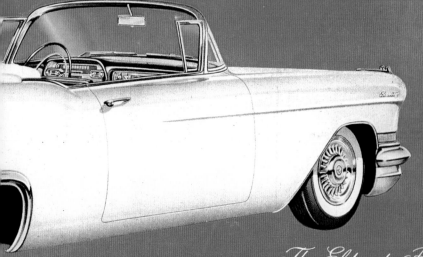

The Eldorado Biarritz

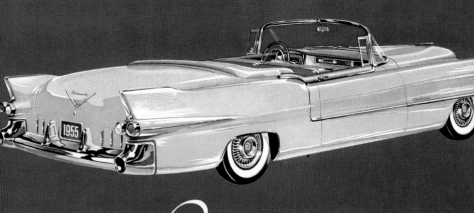

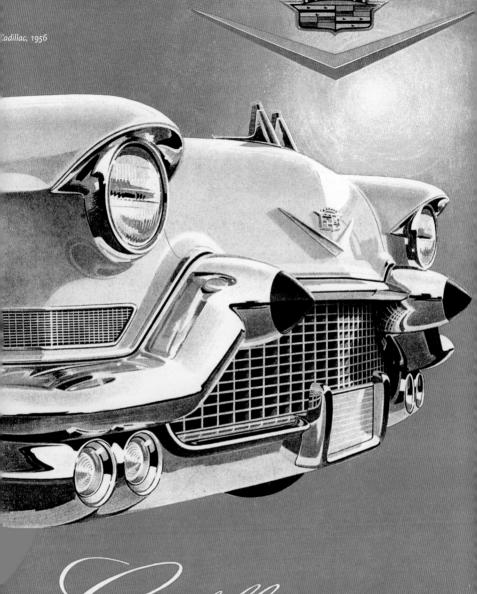

Cadillac, 1956

Cadillac presents

the greatest advancements it has ever achieved

in motor car styling and engineering ! ⟫⟩———————➤

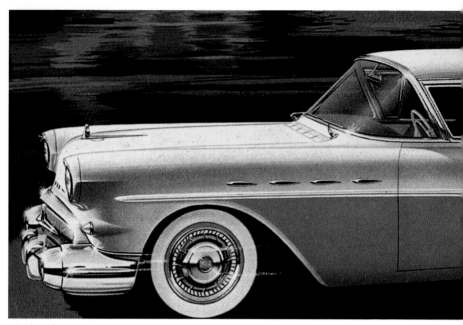

▲Buick Roadmaster, 1957

▼Buick, 1956

▲Oldsmobile, 1959

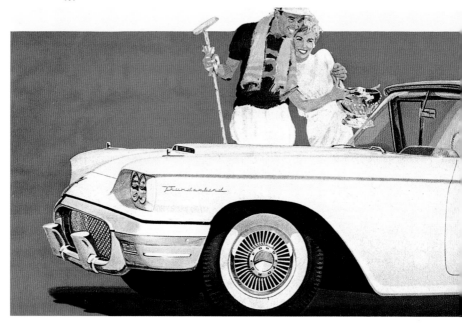

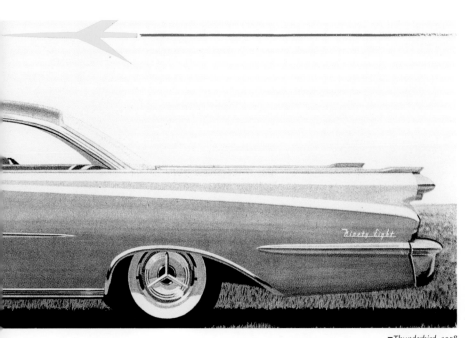

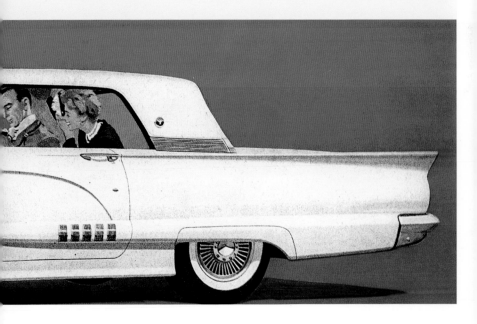

▼*Thunderbird, 1958*

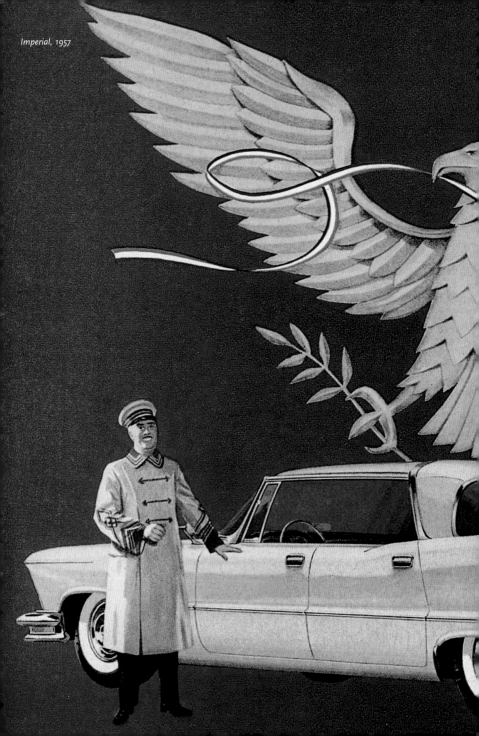

Imperial, 1957

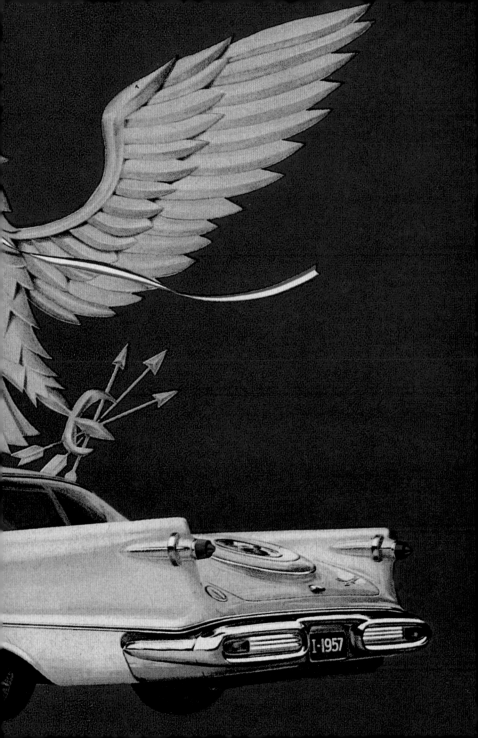

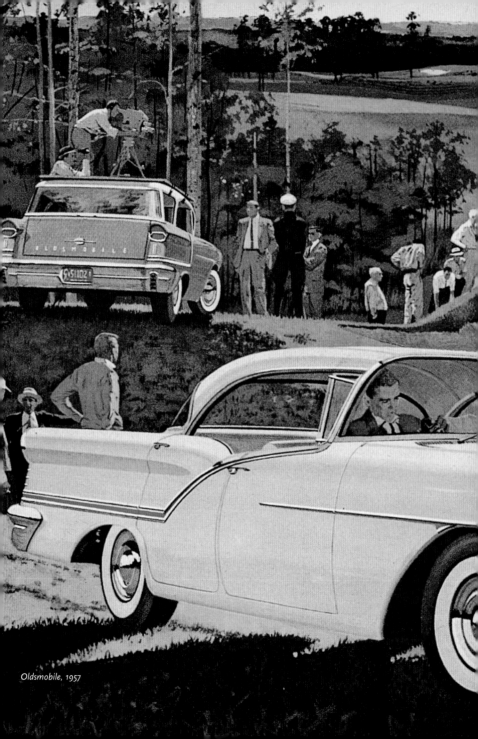

Oldsmobile, 1957

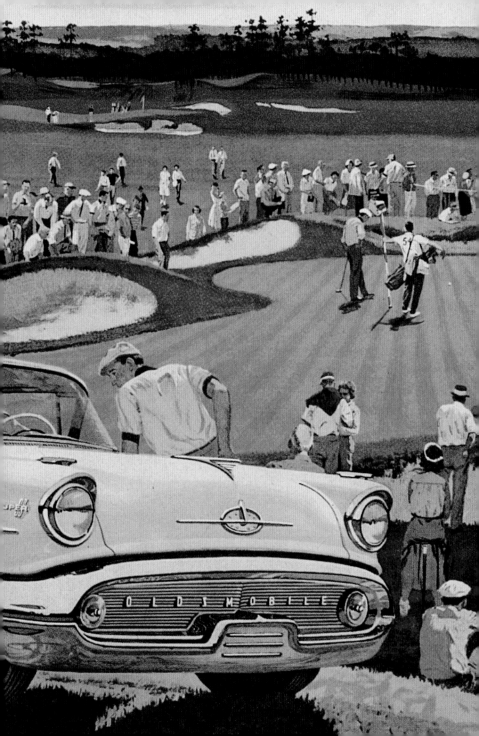

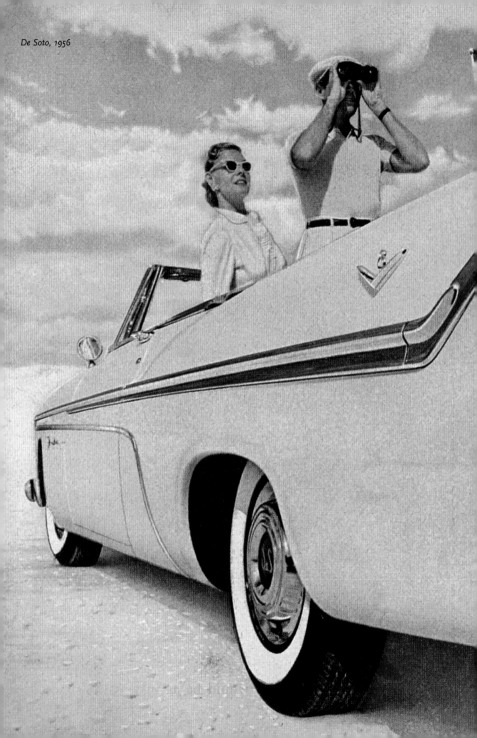

De Soto, 1956

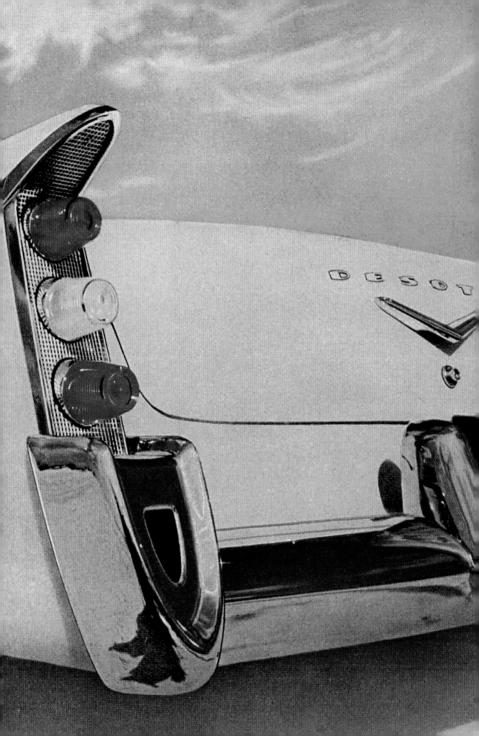

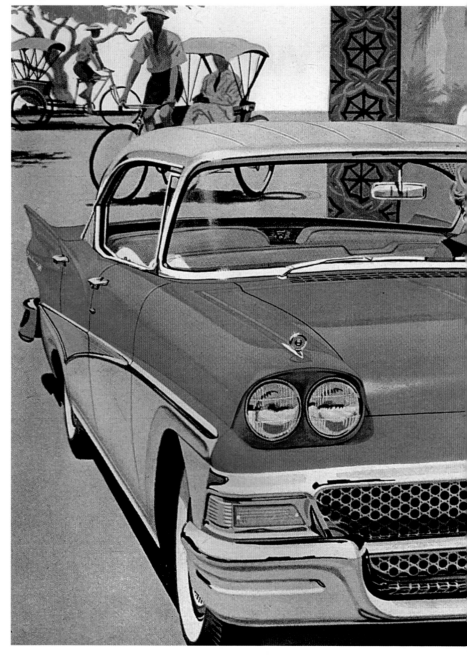

Ford, 1957

'58 CHEVROLET

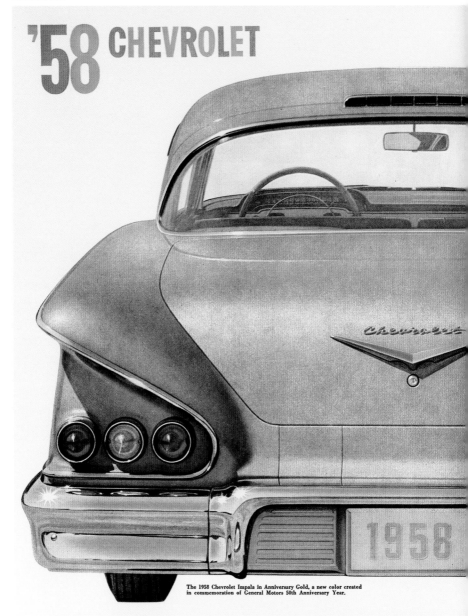

The 1958 Chevrolet Impala in Anniversary Gold, a new color created in commemoration of General Motors 50th Anniversary Year.

The biggest, boldest move any car ever made! *For more about it, turn the page...*

THE CAR: BUICK '59

ELECTRA 225 IN THE EYE-STOPPING NEW 4-DOOR HARDTOP

LE SABRE
The thriftiest Buick

INVICTA
The most spirited Buick

ELECTRA
The most luxurious Buick

Here it is ... and now you know! Know why we have called this THE CAR. Know that a new generation of great Buicks is truly here. From just this one view you can see that here is not just *new* design ... but a splendidly *right* design for this day and age. A car that is lean and clean and stunningly low ... and at the same time great in legroom and easy to get into and out of. From anywhere you look, here is a classic modern concept that is Buick speaking a new language of today. A language of fine cars priced within reach of almost everyone. A language of quality and comfort and quiet pride ... a language of *performance satisfactions* without equal.

New Bodies by Fisher • New Easy
Power Steering* • New Twin-Turbine
and Triple-Turbine automatic
transmissions* • New Wildcat
Engines • New Equipoise Ride
New, improved, exclusive aluminum
front brake drums and fin-cooled
rear brakes
*OPTIONAL AT EXTRA COST ON CERTAIN MODELS.

A NEW CLASS OF FINE CARS WITHIN REACH OF 2 OUT OF 3 NEW CAR BUYERS

▲*Buick, 1959*

▼*Chevrolet, 1957*

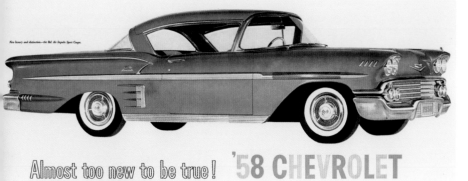

New luxury and distinction—the Bel Air Impala Sport Coupe.

Almost too new to be true!

'58 CHEVROLET

The bold new Bel Air 4-Door Sedan.

The stylish new Nomad Station Wagon.

Here's styling that sets a
new style! The beautiful
'58 Chevrolet is nine
inches longer, four inches
wider and up to 2½ inches
lower.

CHEVROLET

From dual headlights to
gull-wing rear fenders,
these are truly impressive
cars. Interiors, wheel-
bases, grilles, styling
accents, fabrics and ap-
pointments — everything
is new, luxurious, exciting!

*Never, never has a car been so
wonderfully new in so many
different ways! Here are radi-
cal departures in style, power
and ride ... all wrapped up in
the longest, lowest, widest
Chevrolet that ever said,
"C'mon, let's get going!"*

Here are just *some* of the real surprises that await you
in Chevrolet's three new series, its new line of station
wagons, its eye-brightening array of 17 all-new models:

A revolutionary new V8! So new it even looks different
on the outside—that's Chevy's Turbo-Thrust V8*! Combustion
chambers are in the block—a radical design development that
results in super-smooth performance and high efficiency. Horse-
power ranges up to 280. There are three new versions of the
famous Turbo-Fire V8, too, including Ramjet Fuel Injection*,
and more power for the super-thrifty Blue-Flame Six.

New body-frame construction! The secret of Chevy's
road-hugging lowness is the new X-design Safety-Girder frame.
There's extra safety in the lower center of gravity . . . and new
banked-together strength in the way this new frame is welded to
Chevrolet's new Body by Fisher.

All-new 4-coil suspension! Here's a fabulous combination
of super-soft coil springs and the super stability of Chevy's
exclusive four-link rear suspension. Unquestionably, the finest
standard suspension in Chevrolet's field!

You can even ride on air! Level Air suspension* puts air
springs at every wheel for the ultimate in ribbonlike comfort.
It changes every concept of motoring smoothness—and the
car stays level, regardless of load changes front or rear! . . .
See the year's newest car at your Chevrolet dealer's . . .
Chevrolet Division of General Motors, Detroit 2, Michigan.
*Extra-cost option

111

YOUR EYES. YOUR HEART. YO

T

BUICK

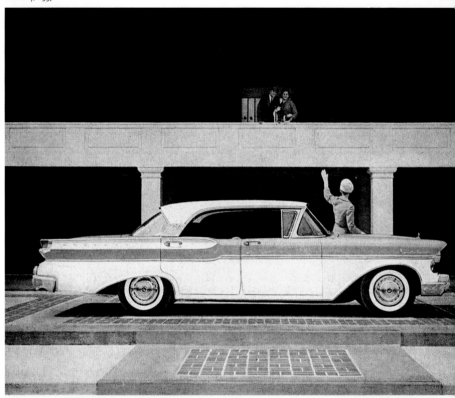

THE MERCURY MONTCLAIR PHAETON SEDAN

Beauty shared by no other car—biggest size and value increase in the industry

EXCLUSIVE DREAM-CAR DESIGN. Here is clean-lined beauty, a massive grace, that is Mercury's alone. Notice the distinctive Jet-Flo bumpers, V-angle tail-lights.

FAMILY-CAR BIG
There's stretch-out comfort for six. This year's Mercury is bigger in 8 vital dimensions inside, 4 outside. There are inches of spare headroom, hip room, shoulder room, and leg room.

PRICED FOR EASY BUYING
Never before has so much bigness and luxury cost so little. See for yourself. Ask your BIG M dealer for the fun-to-read figures, today.

ONLY MERCURY OFFERS YOU THESE 6 DREAM-CAR FEATURES

- Exclusive Dream-Car Design
- Exclusive Floating Ride, with 4 new bump-smothering features
- Exclusive Power-Booster Fan in Montclair Series
- New Merc-O-Matic Keyboard Control
- Power seat that "remembers"
- New Thermo-Matic Carburetor

THE BIG **MERCURY** for '57 *with DREAM-CAR DESIGN*

MERCURY DIVISION • FORD MOTOR COMPANY

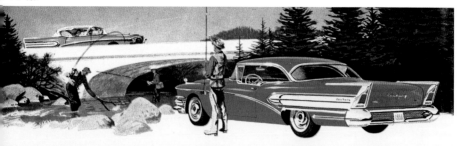

Just born — and bound to make history!

the first big car that's light on its feet —

YOU LOOK at it—and you see "BIG" written all over this bold and beautiful 1958 Buick.

You drive it—and you know that never in all your born days have you known a car so nimble, so eager, so light on its feet.

It took plenty to bring you this easiest-handling, sweetest-riding Buick ever built.

It took a brilliant new engine—the B-12000 —which packs 12,000 pounds of punch behind every piston's power stroke.

It took a brilliantly engineered transmission —Flight Pitch Dynaflow*—that swings its blades through infinite angles of pitch to give precise response to every ounce of pedal pressure.

It took the wonders of the 1958 Buick Miracle Ride—plus the perfection of Buick Air-Poise Suspension*—and Buick Air-Cooled Aluminum Brakes*—and a combination of other modern advances you'll find nowhere but in a 1958 Buick.

But surely you can't be content just to sit there and *read* about all these wonders! Hurry in to your Buick dealer's and *see* and *feel* what he has in store for you!

BUICK *Division of* GENERAL MOTORS

Flight Pitch Dynaflow standard on LIMITED and ROADMASTER 75, optional at extra cost on other Series. Air-Poise Suspension optional at extra cost on all Series. Aluminum Brakes standard on all Series except SPECIAL.

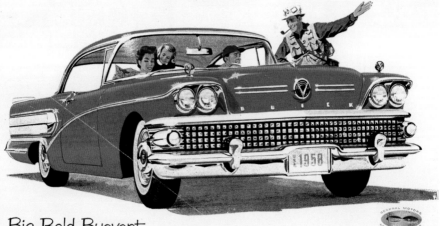

Big·Bold·Buoyant
the AIR BORN B-58 BUICK

Buick, 1957

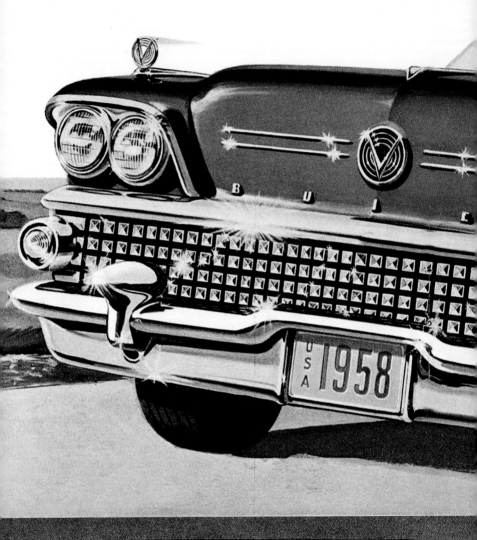

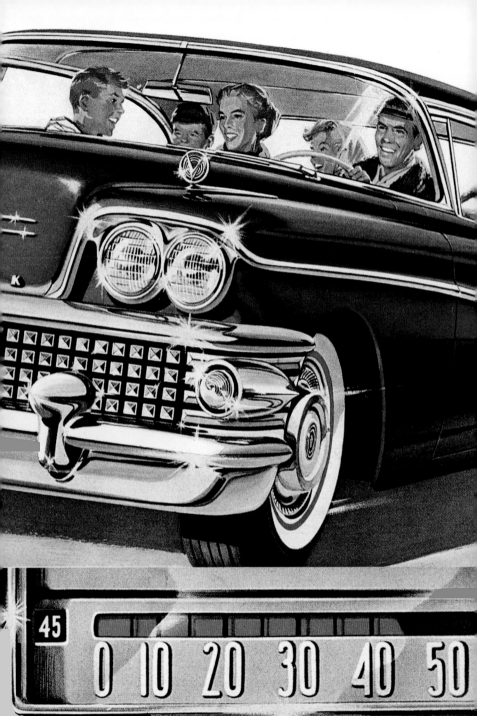

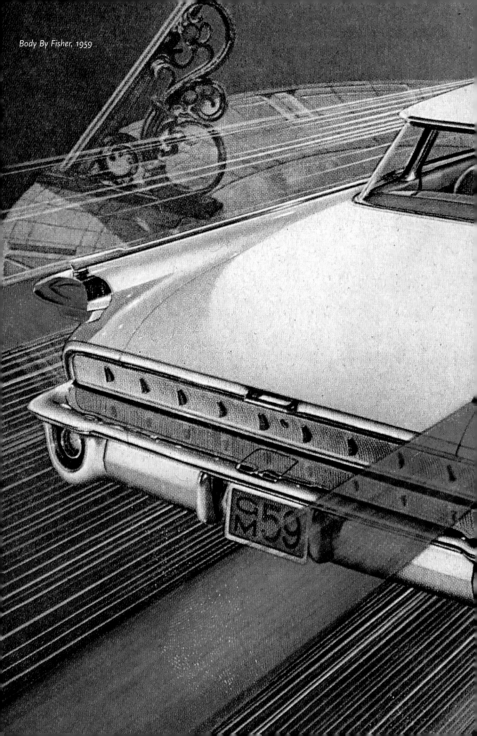

Body By Fisher, 1959

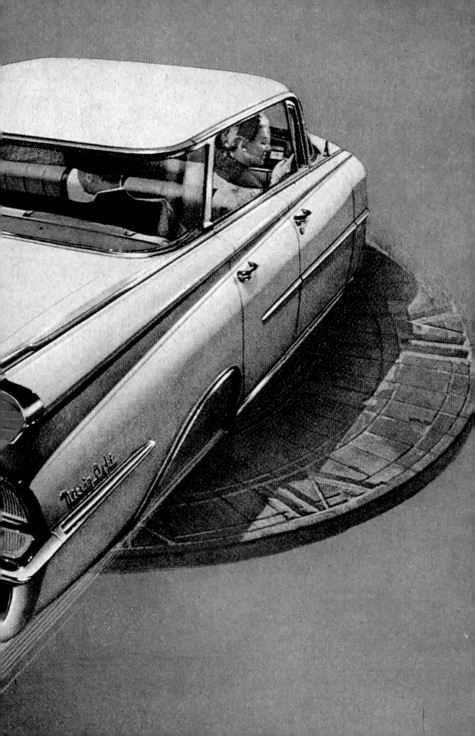

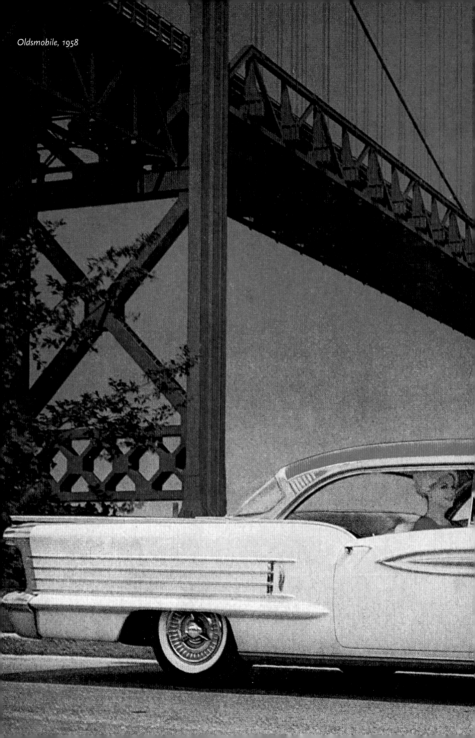

Oldsmobile, 1958

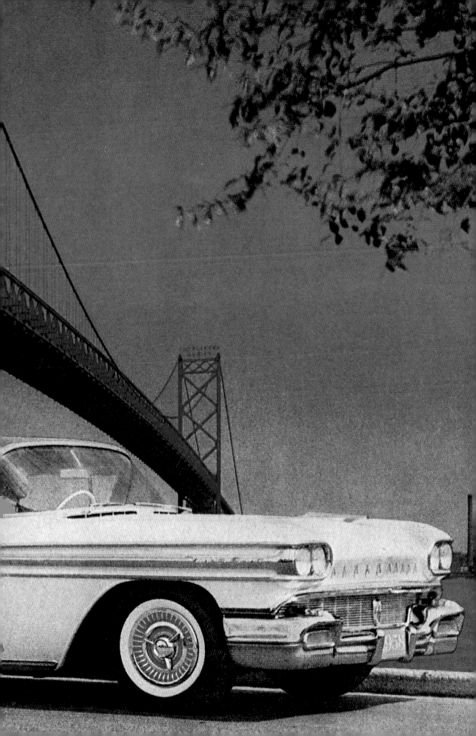

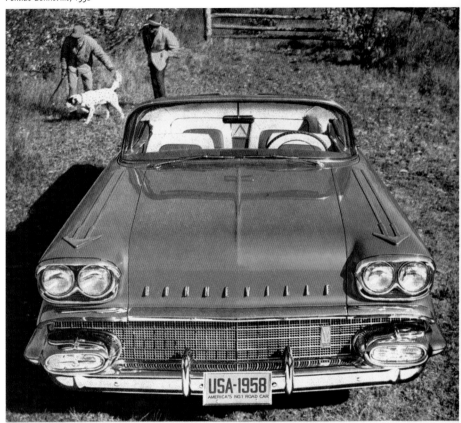

Motoring's Action-packed Aristocrat... Connoisseurs of cars invariably note the unique quality that distinguishes Pontiac's Bonneville from all other fine car breeds. Here, perfectly wedded with an indelible luxury and elegance, is the exhilarating dash and verve of a true high-performance road car! To see and drive the Bonneville, whether the superb Sport Coupe or its equally illustrious teammate, the Convertible, is an unforgettable experience. Why not try it? **BOLD NEW** **Bonneville** *BY* *PONTIAC*

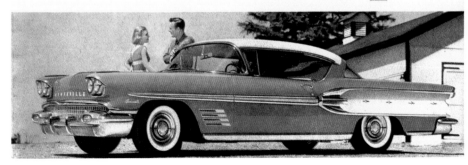

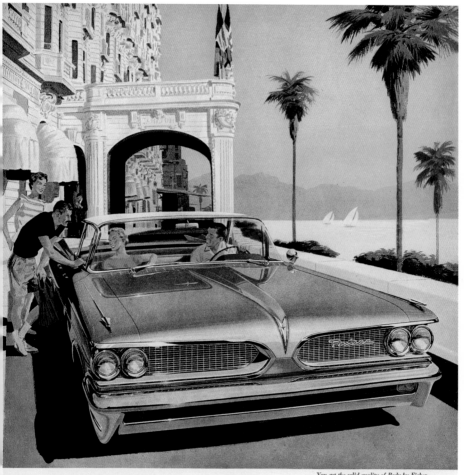

You get the solid quality of Body by Fisher.

Gorgeous new way to save as you go!

Pontiac's new V-8, the Tempest 420E, gives you phenomenal extra mileage—up to 20% saving on gasoline bills!

The same engineers who developed the new Tempest 420 V-8 to give you the ultimate in *action* have also developed a companion power plant with unbelievable gasoline economy! This new engine is a big, easy-breathing V-8 . . . yet it uses *regular gas* and delivers *better mileage* than many of the smaller cars with so-called "economy engines"! Result? *You save up to 20% on gasoline bills!* The secret is in its amazingly efficient design . . . perfected by the industry's hottest engineering team to give you the extra gas mileage you want *without sacrificing V-8 rim and vigor!* So if you have the idea that economy and action just can't go together you're in for a wonderful surprise!

PONTIAC MOTOR DIVISION · GENERAL MOTORS CORPORATION

EXCLUSIVELY YOURS—*WIDE-TRACK* WHEELS

The widest, steadiest stance in America— better cooling for engine and brakes, better grip on the road, safer cornering, smoother ride, easier handling. *You get the most beautiful roadability you're ever known—in America's Number ① Road Car!*

See Victor Borge on Pontiac Star Parade, Nov. 29—CBS-TV

PONTIAC! America's Number ① Road Car!

3 Totally New Series · Catalina · Star Chief · Bonneville

This is the # EDSEL

"A remarkable new automobile joins the Ford family of fine cars"

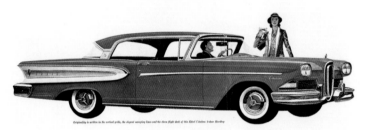

Originality is written in the vertical grille, the elegant sweeping lines and the clean flight deck of this Edsel Citation 2-door Hardtop

There has never been a car like the Edsel. It is a magnificent automobile. Behind it lie all the resources of Ford Motor Company, all the experience and engineering skill.

The results are clear. The Edsel is powered by the newest V-8 engines in the world—the Edsel 400 and the Edsel 475. Their specifications: 400 and 475 pound-feet of torque; 303 and 345 horsepower; 361 and 410 cubic inches of displacement; 10.5 to 1 compression ratio. It is unlikely you have ever driven a car with so much usable power.

The Edsel's big, safe brakes do not need periodic adjustment. In the course of daily driving, they adjust automatically.

The Edsel shifts itself. In an Edsel equipped with Teletouch Drive, you just touch a button on the steering wheel hub. Teletouch Drive does the rest—smoothly, surely, safely, electrically.

The Edsel's list of available new features is long. Examples: contour seats; a dial that lets you select temperature, quantity and direction of air with one twist of the wrist; a warning signal that flashes when you exceed your pre-set speed limit; another that flashes when oil is one quart low; a release that enables you to open the luggage compartment from the driver's seat. You will find there are many things that make the Edsel different from any car you have ever driven. More exciting, more sure, more safe.

What does an Edsel cost? Edsel prices range from just above the lowest to just below the highest. You can afford an Edsel. And you can choose from four series, 18 models. Your Edsel Dealer invites you to see and drive the Edsel—soon.

EDSEL DIVISION · FORD MOTOR COMPANY

EDSEL

NOW AT YOUR EDSEL DEALER

▲ *Edsel, 1958* ▼ *Thunderbird, 1958* ▶ *Diamond Chemicals, ca. 1957*

Ford presents a brilliant new version of a great classic...the 4-passenger

THUNDERBIRD

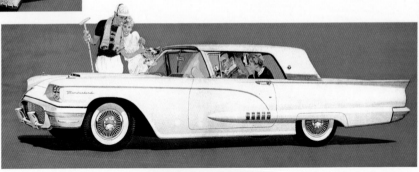

America's most individual car...an automotive jewel that's pure Thunderbird in design, spirit and performance...with full fine-car room, comfort and luxury for four

Another first from Ford! In the 1958 Thunderbird, Ford has created a wholly new size and type of fine car. It gives you Thunderbird compactness, Thunderbird handling and traditional Thunderbird performance— yet, miraculously, it now gives you full fine-car room and comfort for four people! It brings you interior appointments that are unbelievably imaginative and luxurious. Now, happily, you can share your Thunderbird thrills with deserving friends. Now it's *twice the fun* to own the car that became an American classic the very day it was introduced. For details about America's most excitingly different car,

turn the page, please

124

Diamond's Guide to Car Watching
(can you identify them?)*

Here are the southern exposures of nine northbound 57's. Dramatically different as these new cars are, they have one thing in common. On each is some chrome plating that started with DIAMOND Chromic Acid. DIAMOND ALKALI is one of the world's largest producers of chromium chemicals, and DIAMOND research has recently developed a new additive for chrome platers which reduces plating time and cost, gives a harder, brighter finish.

Progress like this helps explain why DIAMOND's "Chemicals you live by" are preferred by so many industries, found in so many places.
DIAMOND ALKALI COMPANY, Cleveland 14, Ohio.

Diamond
Chemicals

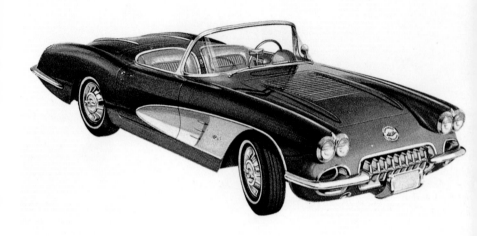

Chevrolet, 1958

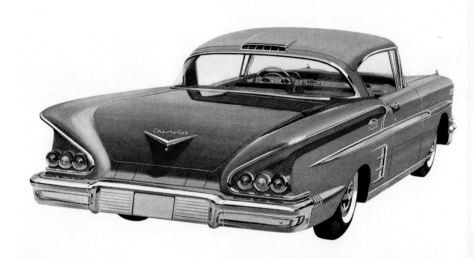

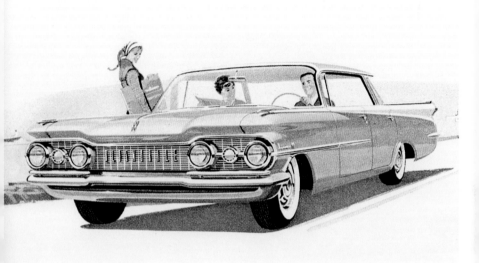

Oldsmobile, 1959

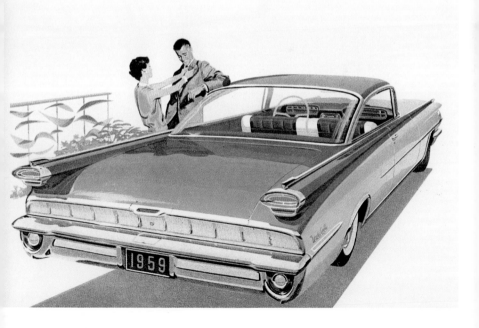

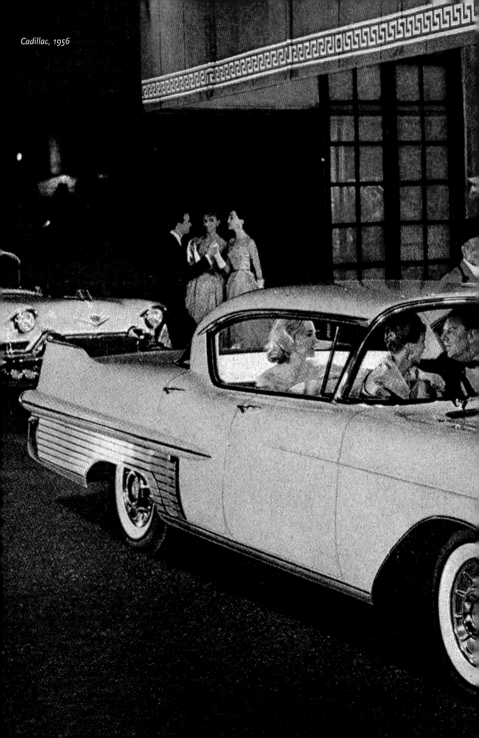

Cadillac, 1956

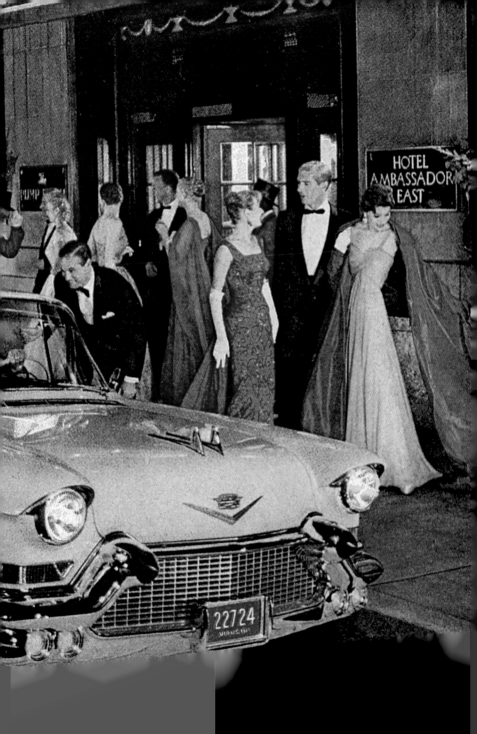

Plymouth, 1955

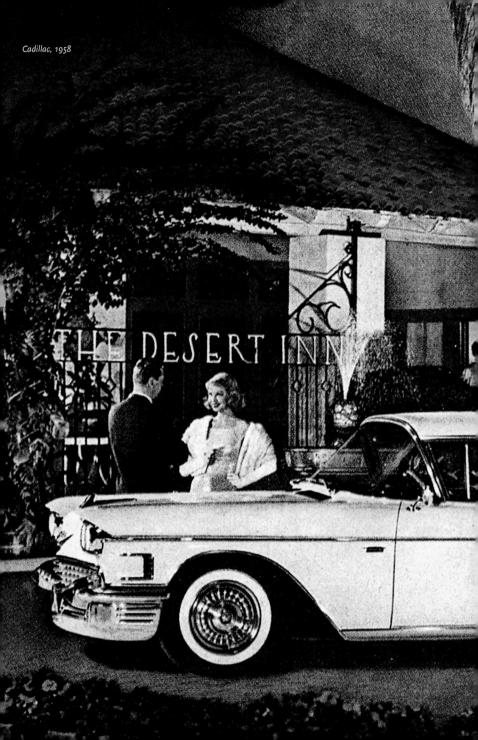

Cadillac, 1958

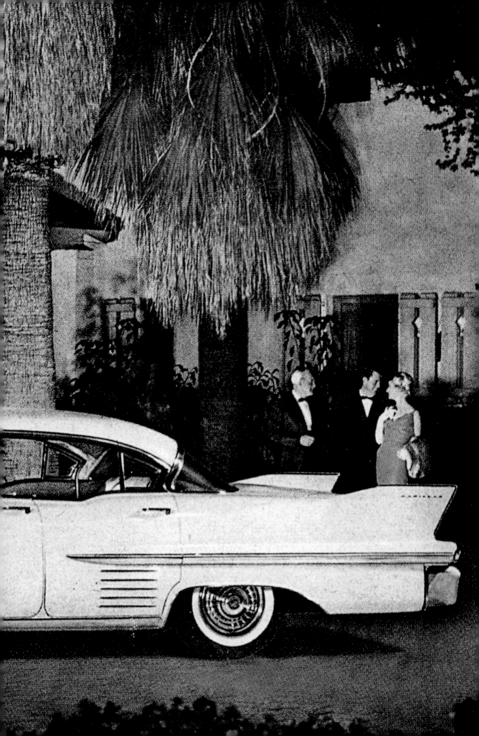

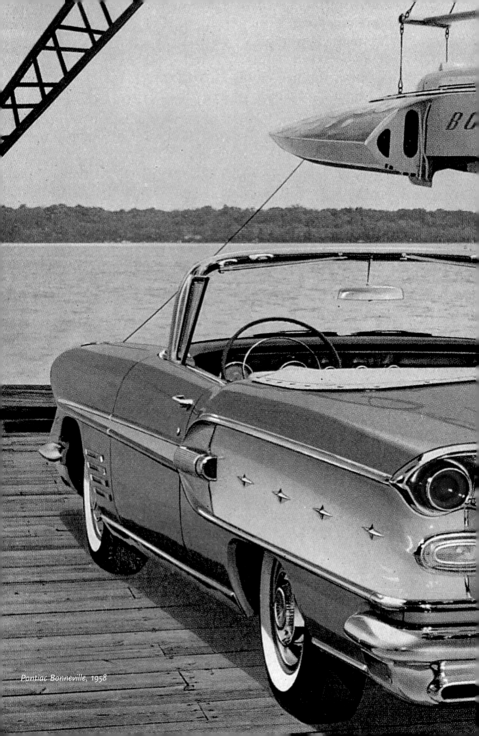

Pontiac Bonneville, 1958

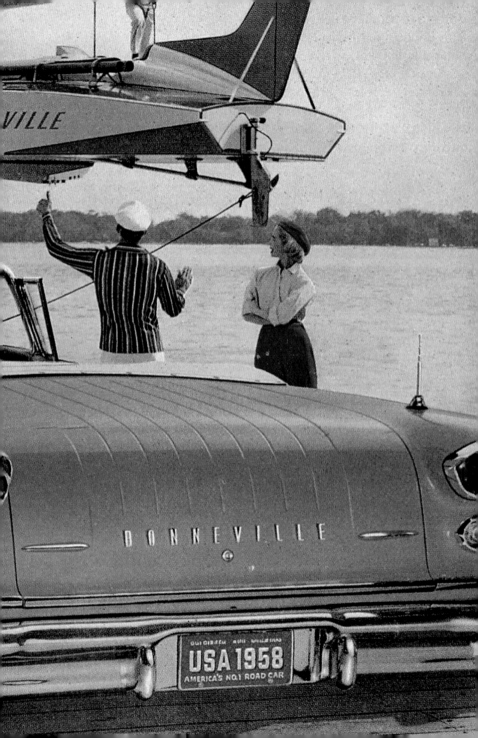

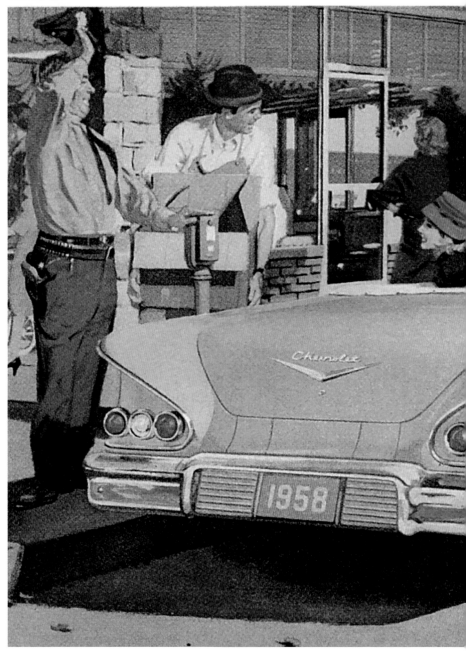

Chevrolet, 1958

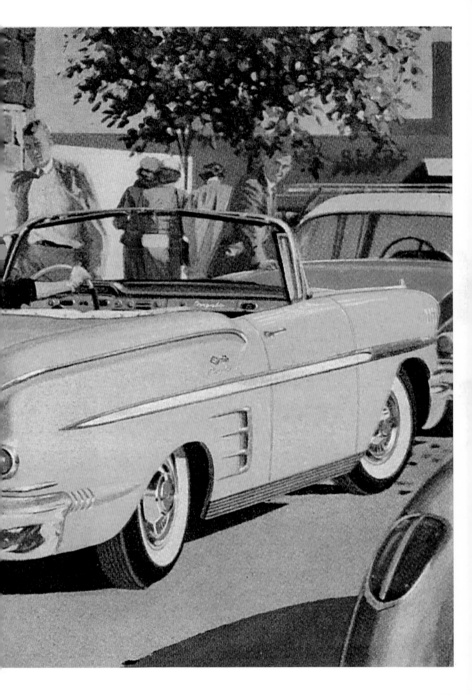

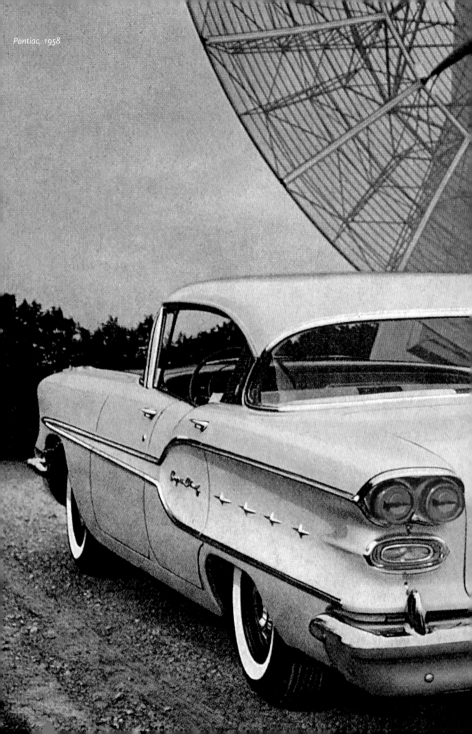

Pontiac, 1958

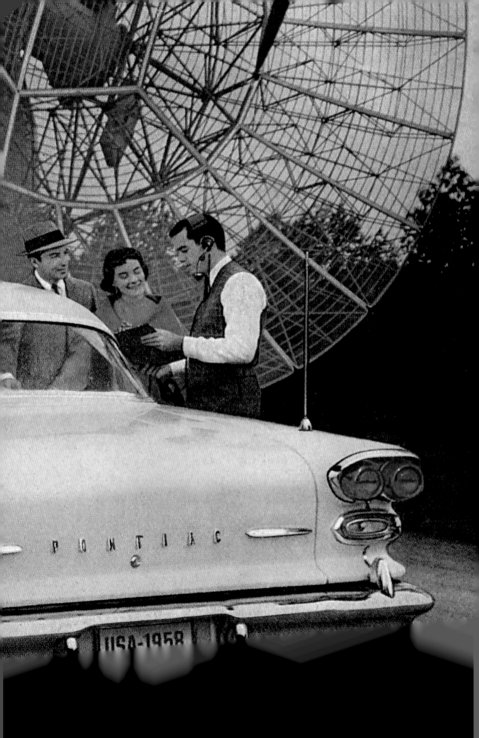

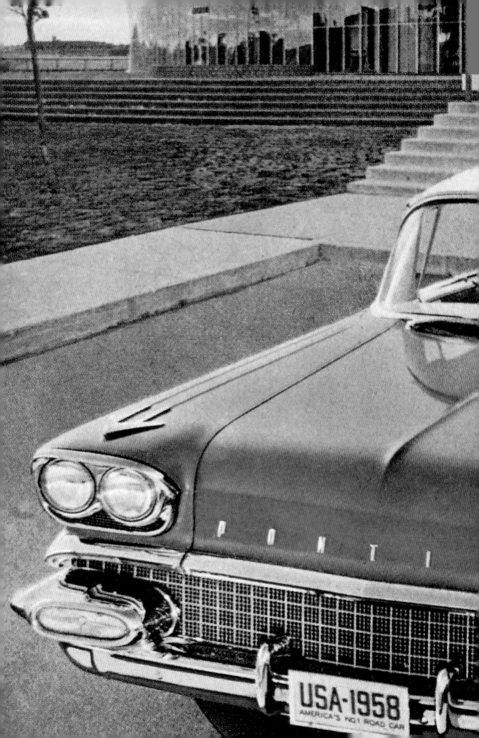

USA-1958
AMERICA'S No1 ROAD CAR

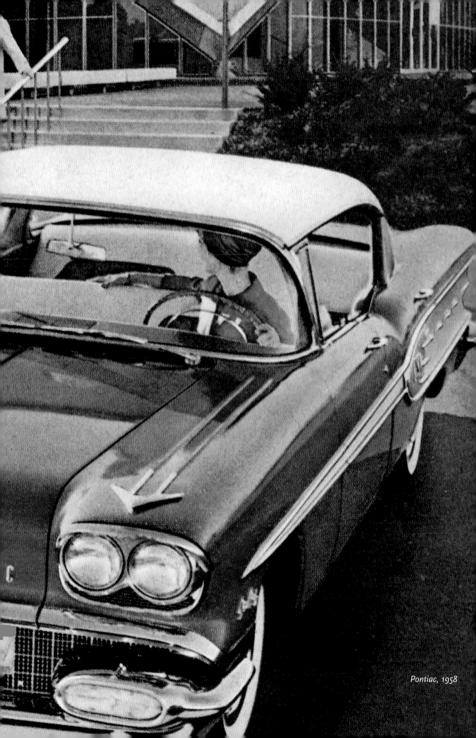

Pontiac, 1958

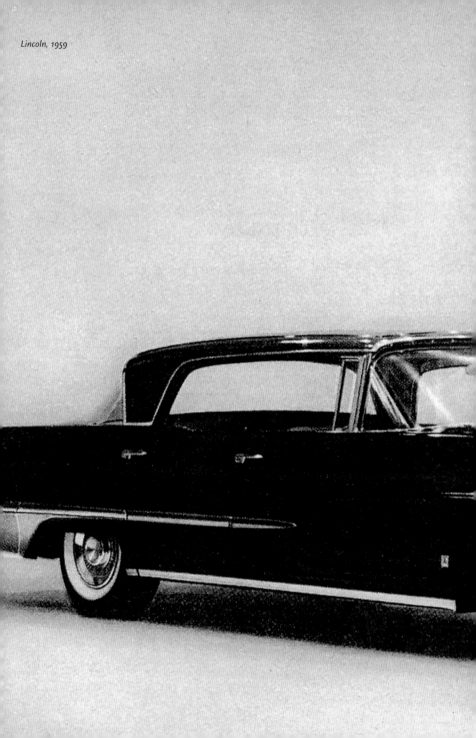
Lincoln, 1959

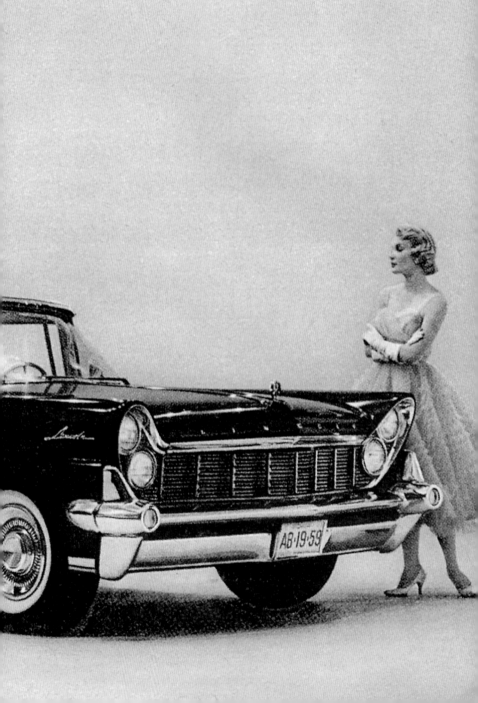

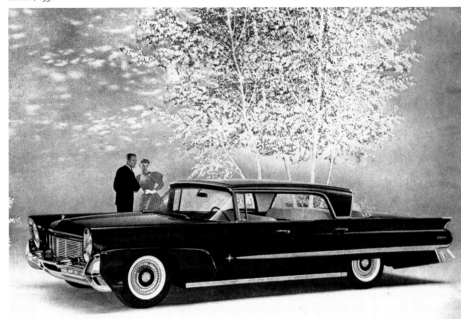

Classic elegance in motorcars: The Lincoln Landau. Gown by Traina-Norell

THE CLASSIC FINE CAR

that brings Continental luxury within the reach
of every fine car buyer

THE NEW LINCOLN

styled and crafted in the classic Continental tradition

Inspiration for The New Lincoln: the new Continental Mark III.
Mark III prices are just slightly above the fine car field.

The New Lincoln—styled and crafted in the Continental tradition—has created a new standard by which all fine cars must now be measured.

For the first time, every fine car owner has the opportunity to know Continental standards of luxury, driving qualities and craftsmanship.

The man who owns a Lincoln drives a car of classic beauty. And as he drives, he knows the pleasure of being surrounded by classic elegance in interiors.

The Lincoln owner knows an engine built to a whole new standard of precision tolerances . . . and in the Continental ideal of luxurious, *effortless* driving—every power assist known.

We invite your inspection of the first distinctively new choice in fine cars in many, many years.

LINCOLN DIVISION, FORD MOTOR COMPANY

Now, in America, a refreshing new concept in fine motor cars

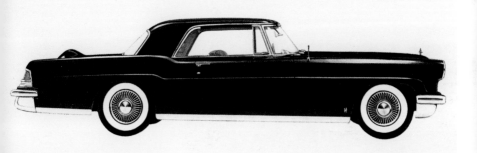

The excitement it stirs in your heart when you see the
Continental *Mark II* lies in the way it has dared to de-
part from the conventional, the obvious.

And that's as we intended it. For in designing and
building this distinguished motor car, we were thinking,
especially, of those who admire the beauty of honest,
simple lines . . . and of those who most appreciate a car
which has been so conscientiously crafted.

The man who owns a Continental *Mark II* will possess
a motor car that is truly distinctive and will *keep* its
distinction for years to come.

Continental
Mark II

Continental Division · Ford Motor Company

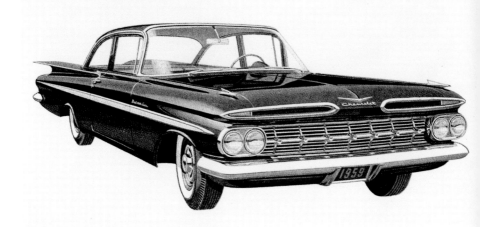

▲Chevrolet, 1959

▼Buick, 195

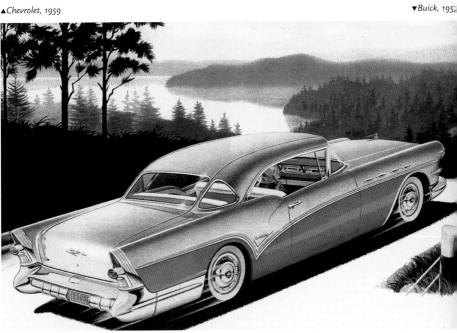

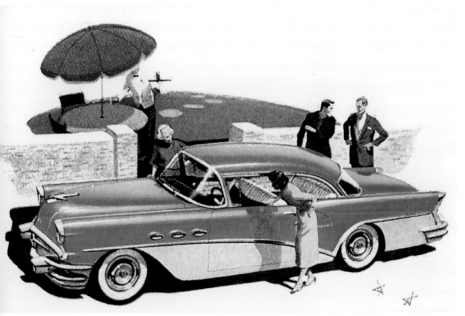

▲*Buick, 1956*

▼*Oldsmobile, 1959*

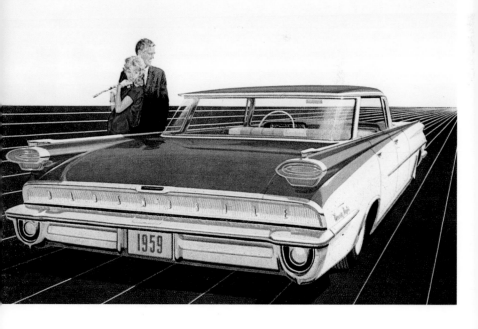

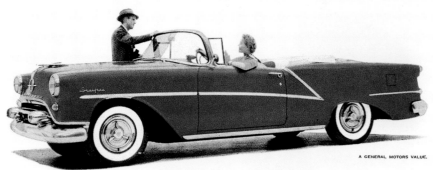

OLDSMOBILE'S

FABULOUS NEW "*Starfire*"

NOW IN PRODUCTION!

Starfire—the "show car" that can be your car! *Starfire*—with a long, rakish, waist-high silhouette . . . smartly curving panoramic windshield and spectacular sweep-cut rear fenders . . . saddle-stitched leather interior in dramatic new two-tone patterns. *Starfire*—with the surging might of a new 185-horsepower "Rocket" Engine! See and drive this glamorous new Oldsmobile convertible—the "Dream Car" Ninety-Eight *Starfire*—at your Oldsmobile dealer's now.

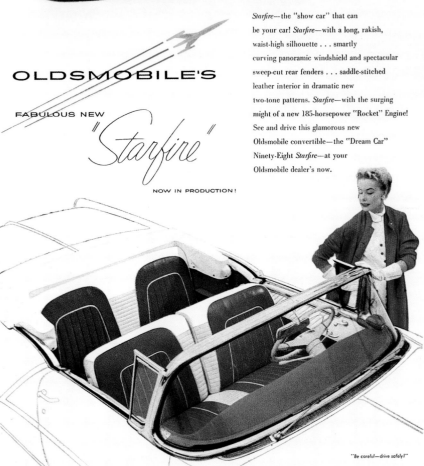

"Be careful—drive safely!"

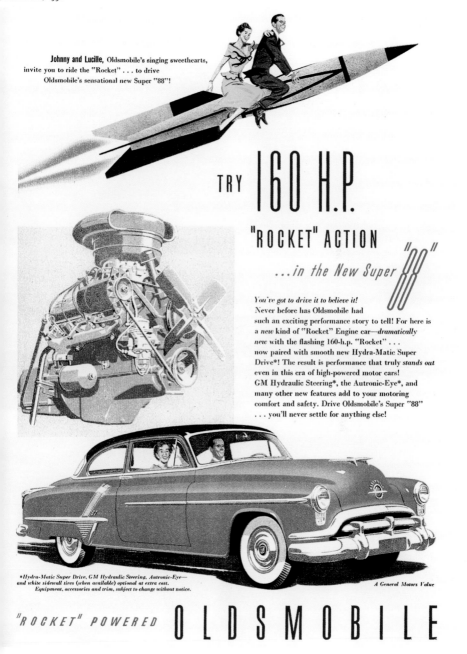

Johnny and Lucille, Oldsmobile's singing sweethearts, invite you to ride the "Rocket" . . . to drive Oldsmobile's sensational new Super "88"!

TRY **160 H.P.**

"ROCKET" ACTION

. . . in the New Super "88"

You've got to drive it to believe it!
Never before has Oldsmobile had
such an exciting performance story to tell! For here is
a *new* kind of "Rocket" Engine car—*dramatically
new* with the flashing 160-h.p. "Rocket" . . .
now paired with smooth new Hydra-Matic Super
Drive*! The result is performance that truly *stands out*
even in this era of high-powered motor cars!
GM Hydraulic Steering*, the Autronic-Eye*, and
many other new features add to your motoring
comfort and safety. Drive Oldsmobile's Super "88"
. . . you'll never settle for anything else!

*Hydra-Matic Super Drive, GM Hydraulic Steering, Autronic-Eye—
and white sidewall tires (when available) optional at extra cost.
Equipment, accessories and trim, subject to change without notice.

A General Motors Value

"ROCKET" POWERED **OLDSMOBILE**

149

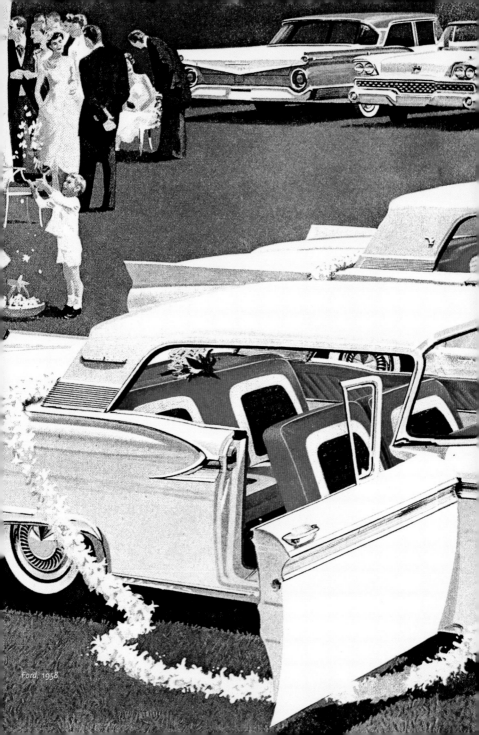

Ford, 1958

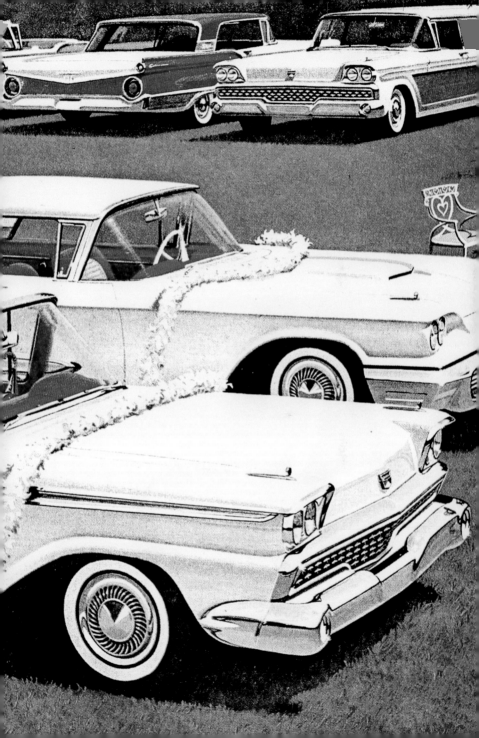

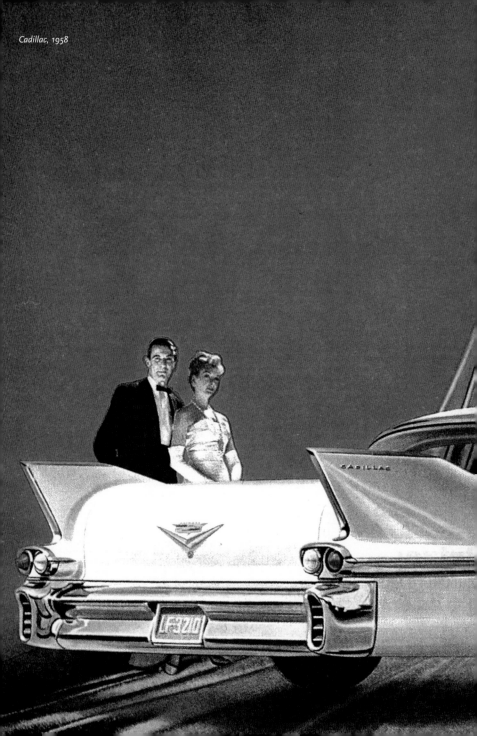

Cadillac, 1958

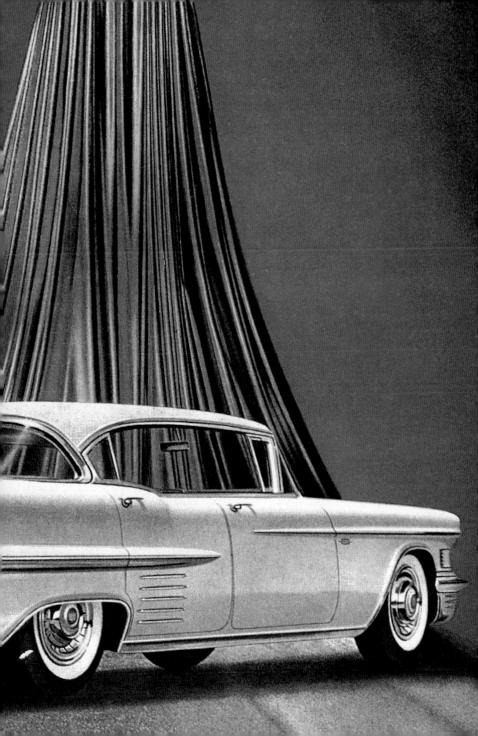

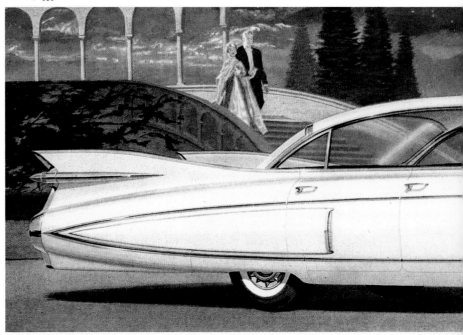

THE FLEETWOOD SIXTY SPECIAL

A NE

THE 1959 *Cadillac*

By appointment to the world's most discriminating motor

THE ELDORADO BIARRITZ

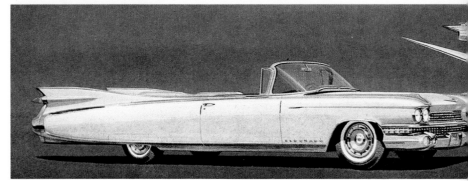

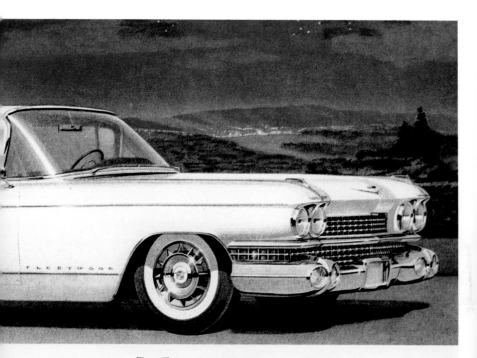

EALM OF MOTORING MAJESTY!

agle glance tells you these are the newest and most mag-
ent Cadillac cars ever created. Dazzling in their beauty,
e and elegance, and inspiring in their Fleetwood luxury
decor—they introduce a new realm of motoring majesty.
a single journey at the wheel will reveal still another fact
at these are the finest performing Cadillacs ever produced.
a spectacular new engine, more responsive Hydra-Matic

drive and improved qualities of ride and handling, they
provide a totally new sense of mastery over time and dis-
tance. This brilliant new Cadillac beauty and performance
are offered in thirteen individual body styles. To inspect
and to drive any of them is to acknowledge Cadillac a
new measure of supremacy. We invite you to do both—soon!

CADILLAC MOTOR CAR DIVISION • GENERAL MOTORS CORPORATION

THE SIXTY-TWO COUPE

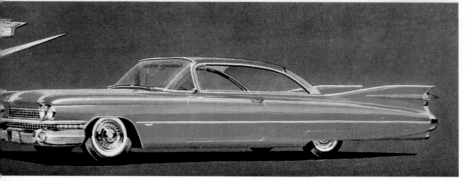

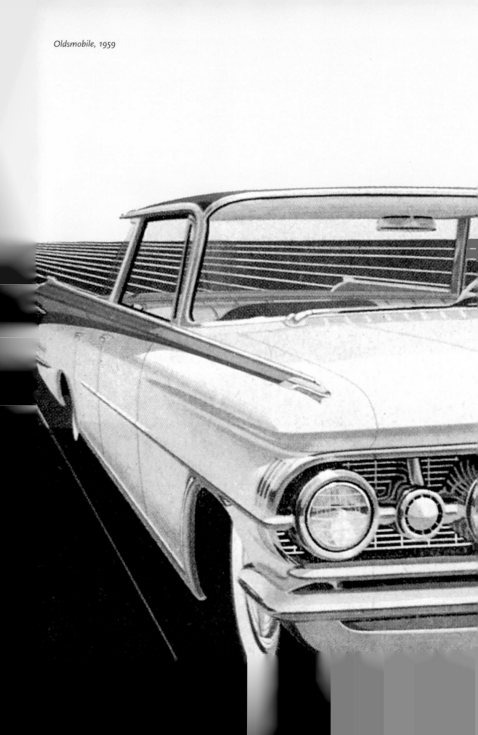

Oldsmobile, 1959

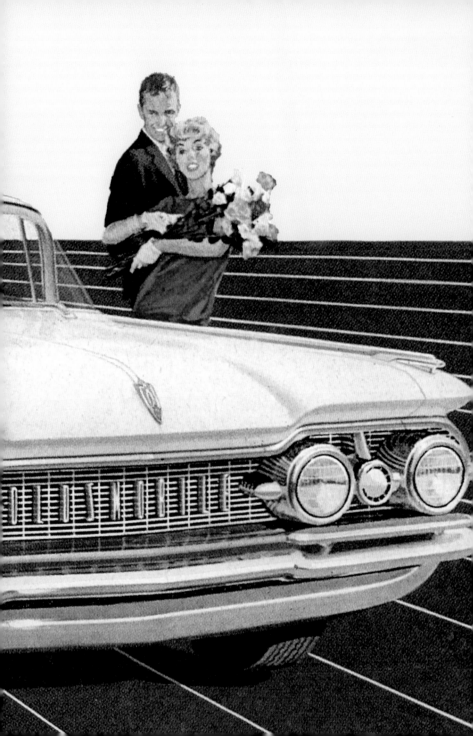

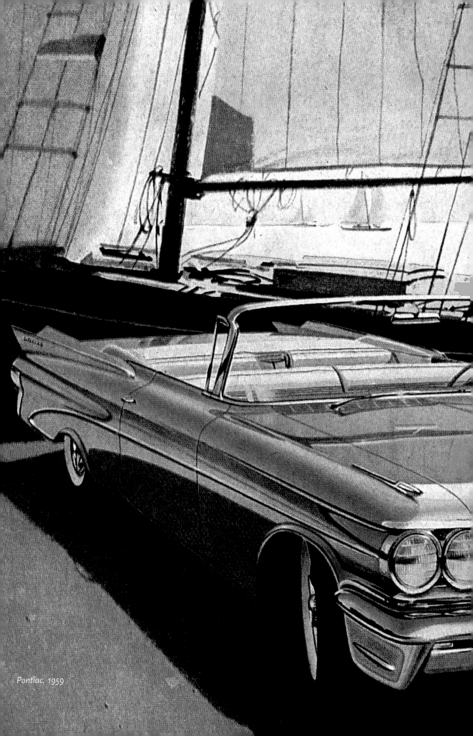

Pontiac, 1959

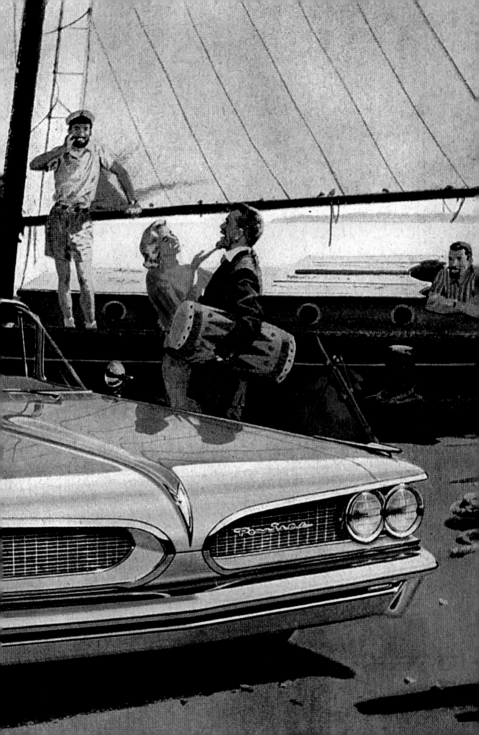

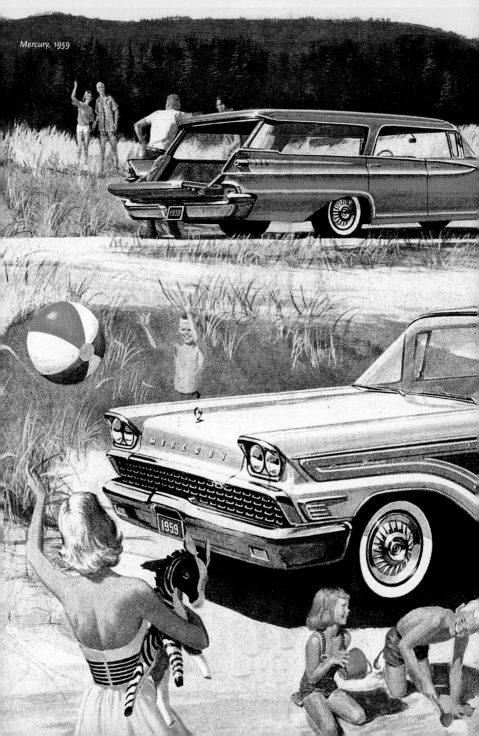

Mercury, 1959

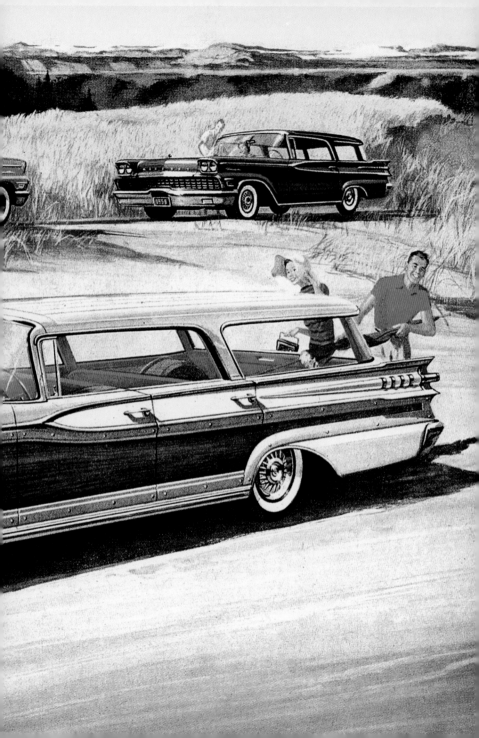

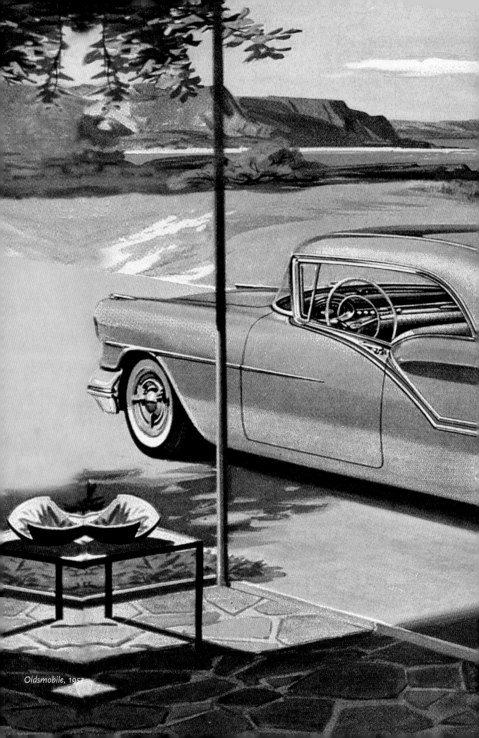

Oldsmobile, 1957

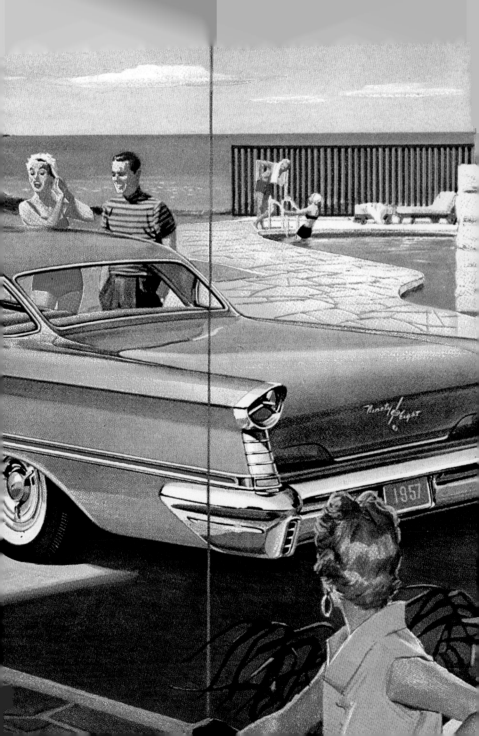

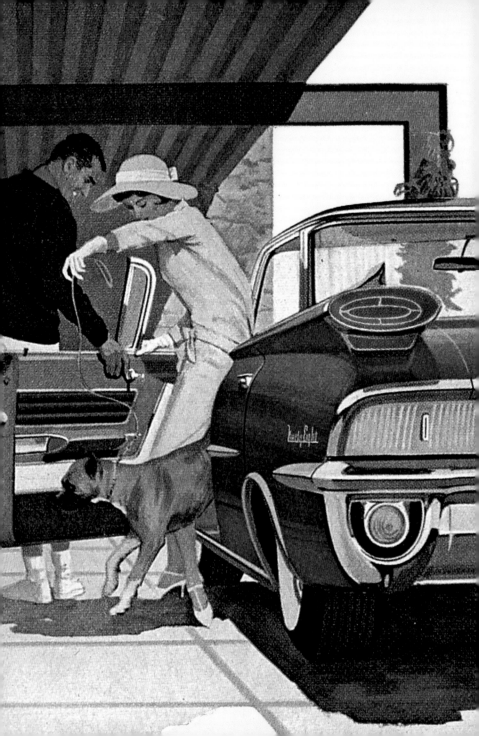

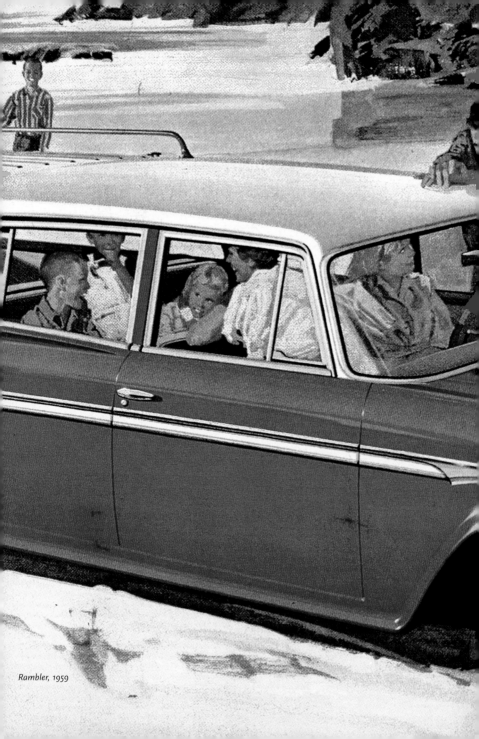

Rambler, 1959

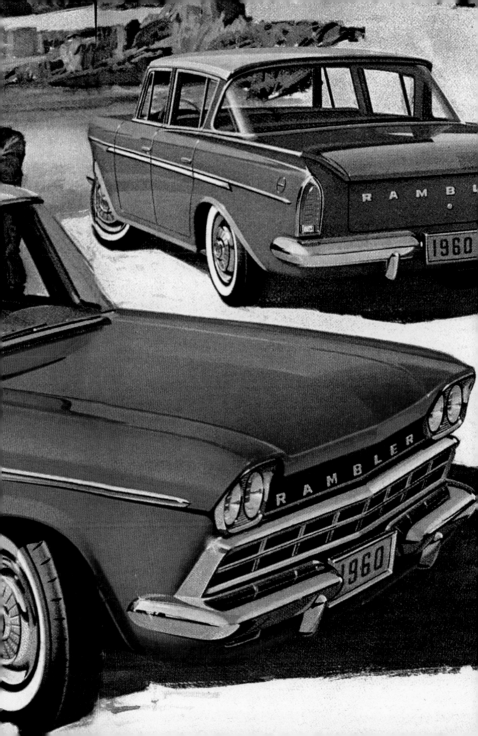

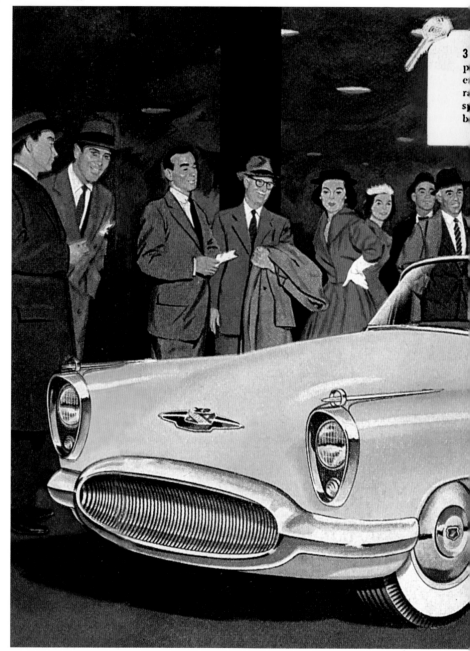

er Performance from a 550-Pound Motor—GM engineers solved the problem of
y high-powered engine in small space by developing an entirely new light alloy
th of these cars. The engine is a supercharged V-8 having 10 to 1 compression
erating on premium-grade fuel for all normal driving—premium fuel plus
uitable for supercharged engines at higher speeds. Engines are supercharged
GM engineers developed for Diesel engines.

Once around with J-WA

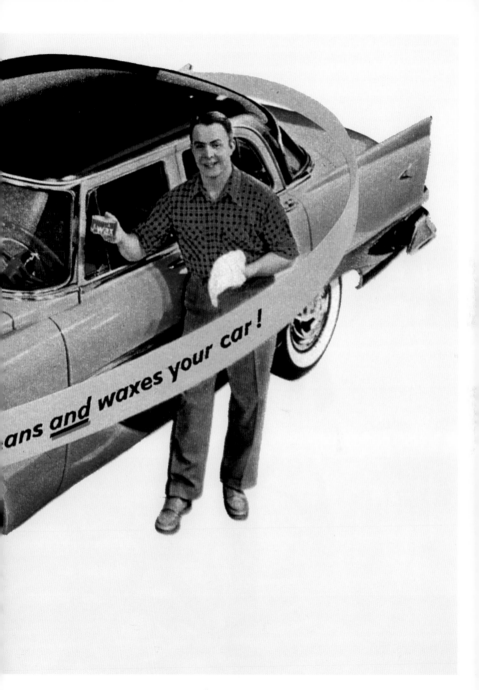

...ans _and_ waxes your car!

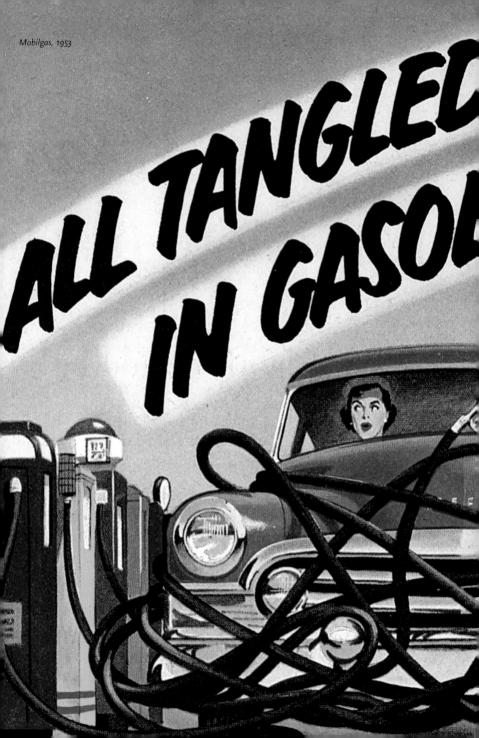

Mobilgas, 1953

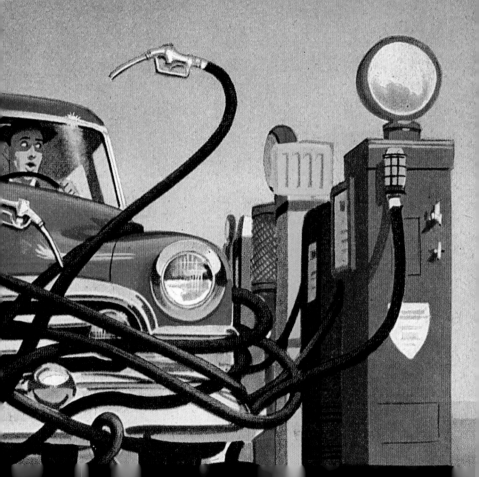

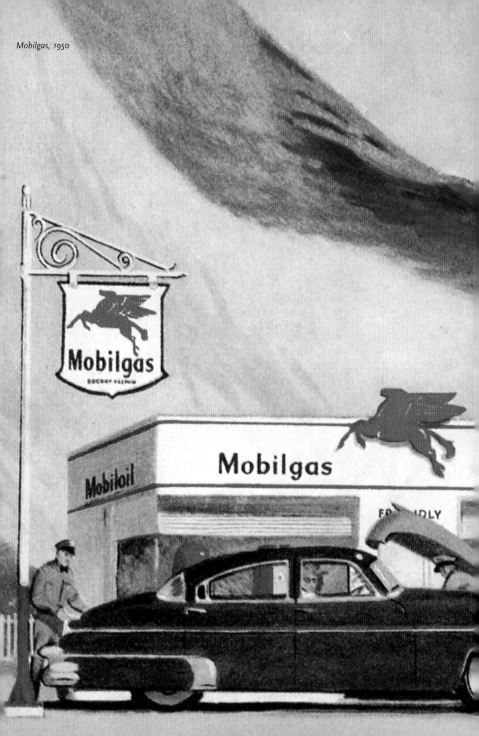

Mobilgas, 1950

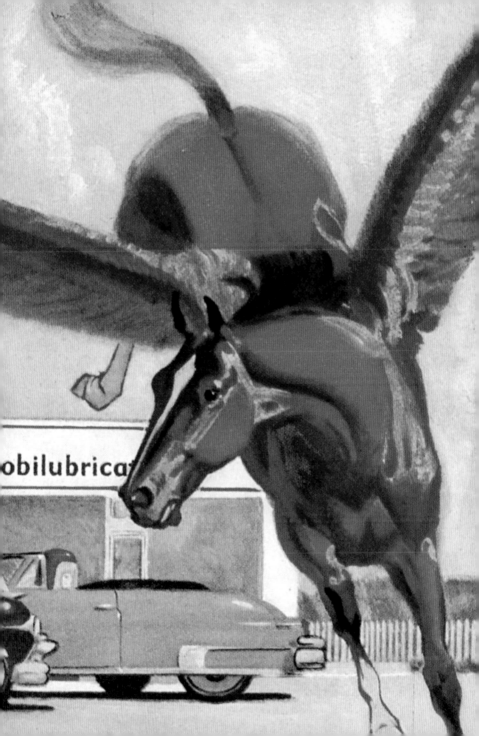

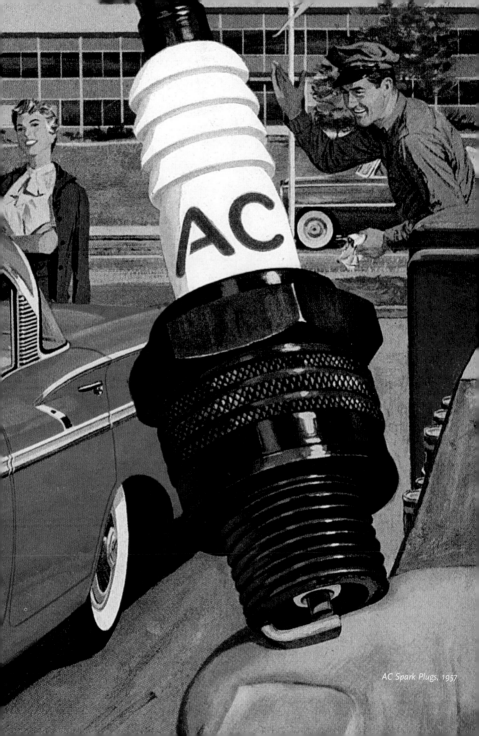

AC Spark Plugs, 1957

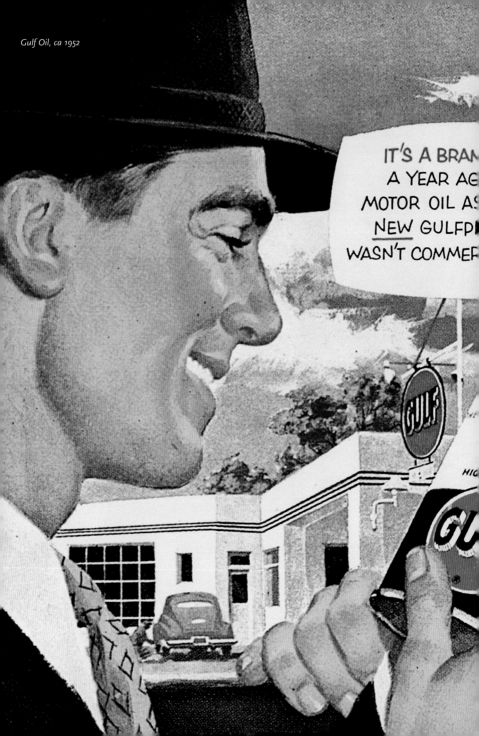

Gulf Oil, ca 1952

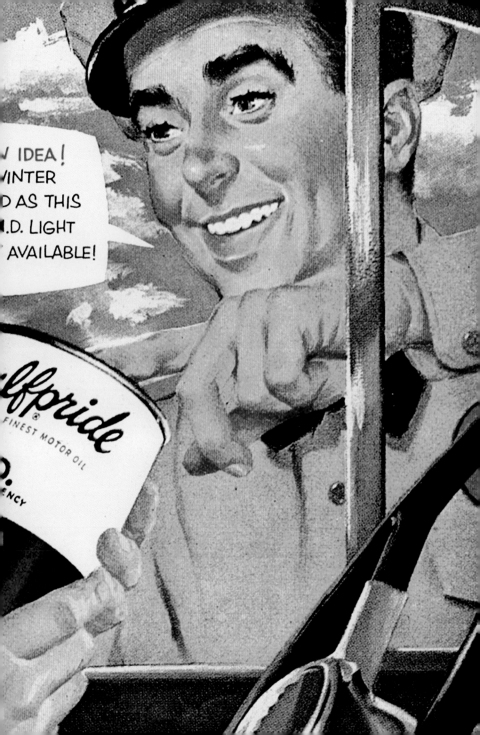

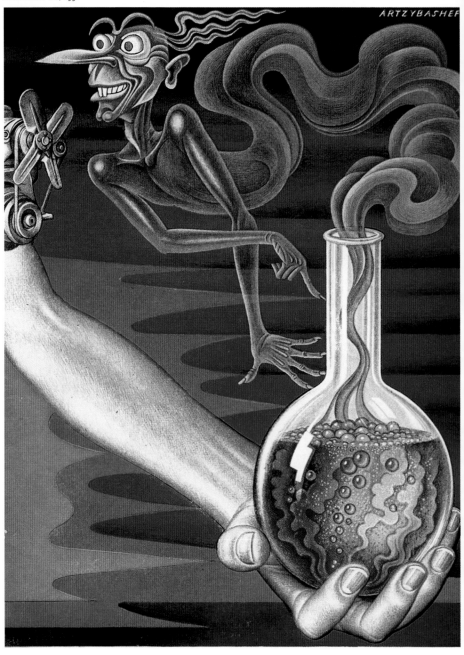

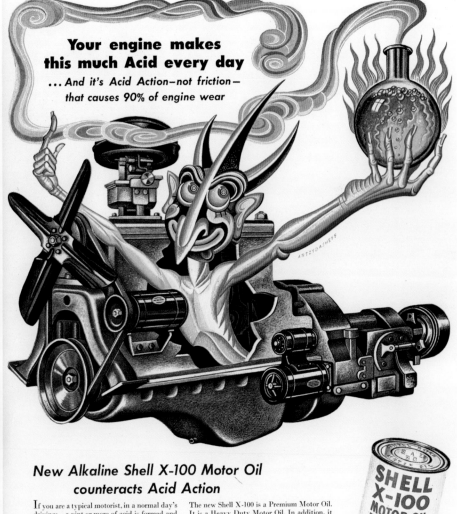

Your engine makes this much Acid every day

... And it's Acid Action—not friction— that causes 90% of engine wear

New Alkaline Shell X-100 Motor Oil counteracts Acid Action

If you are a typical motorist, in a normal day's driving:—a pint or more of acid is formed and passes through your car's engine, and it's acid action, not friction, that causes 90% of your engine wear. To neutralize the harmful effect of this acid, Shell Research has produced an alkaline motor oil—Shell X-100. Fortified with alkaline "X" safety factors, it neutralizes the acid action, prolonging the life of your engine.

The new Shell X-100 is a Premium Motor Oil. It is a Heavy Duty Motor Oil. In addition, it contains positive cleansing factors that help protect hydraulic valve lifters and other vital parts from fouling deposits.

Shell X-100 is the finest motor oil money can buy. Let your Shell dealer give your engine the protection of this new alkaline Shell X-100 Motor Oil today.

It's Incomparable!

SHELL X-100 MOTOR OIL PREMIUM-HEAVY DUTY

Quaker State Motor Oil, 1953

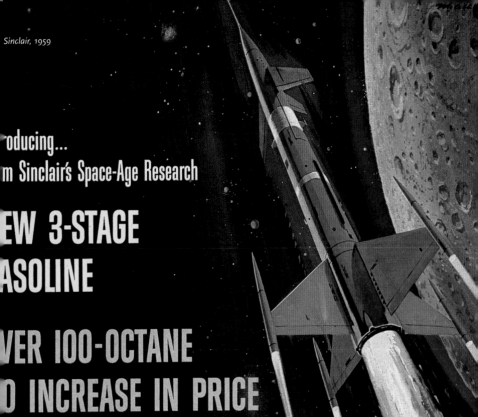

Sinclair, 1959

...oducing...
...m Sinclair's Space-Age Research

...EW 3-STAGE
...ASOLINE

...VER 100-OCTANE
...O INCREASE IN PRICE

New Sinclair Power-X Gives You 100-Octane Performance in All 3 Driving Stages

1 STARTING Power-primed with rocket fuel, new Power-X Gasoline is over 100-octane! You start quick as a click in any weather...and your engine warms up smooth and sweet. No stalling, no skipping.

2 ACCELERATION 12,000 pounds thrust at the touch of your toe! No need for fancy super-priced gasolines. With new Power-X, you get lightning getaway...reserve power for smoother, safer driving.

3 MILEAGE Those extra octanes mean extra economy, too...more miles in every thrifty gallon. And there's no increase in price! Watch for the new Power-X at your neighborhood Sinclair Dealer's Station.

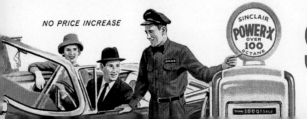

NO PRICE INCREASE

SINCLAIR **POWER-X** OVER 100 OCTANE

SINCLAIR

WATCH FOR THE ARRIVAL OF NEW POWER-X GASOLINE IN YOUR COMMUNITY

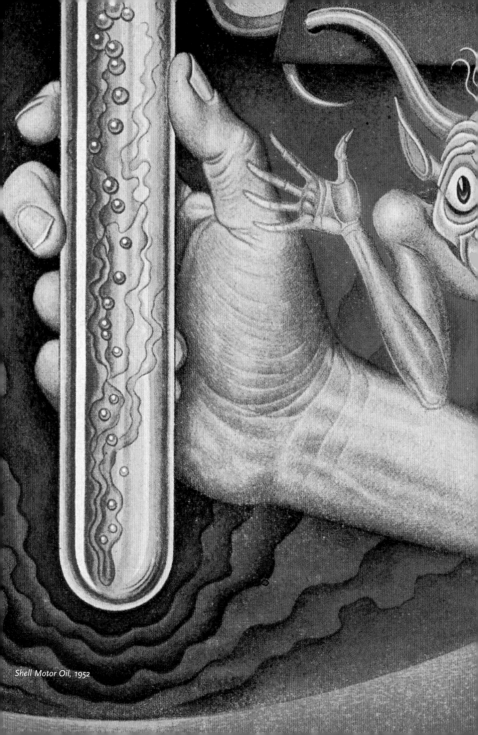

Shell Motor Oil, 1952

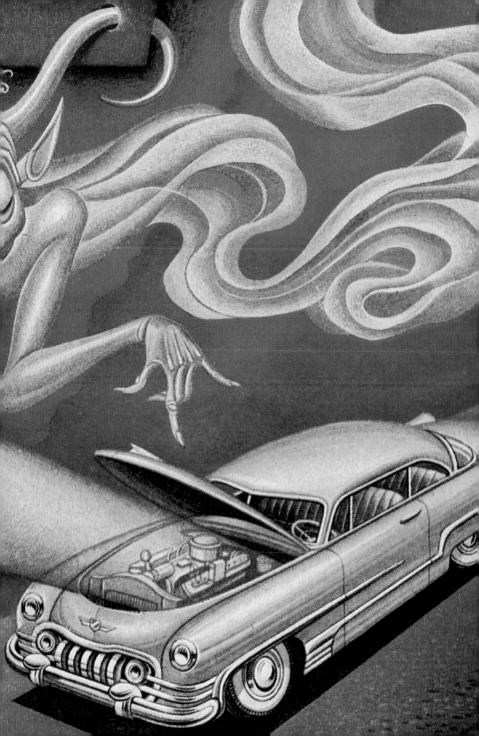

WASHING GULFLEX

Gulf Oil 1957

Nash Thought of
in the World's F

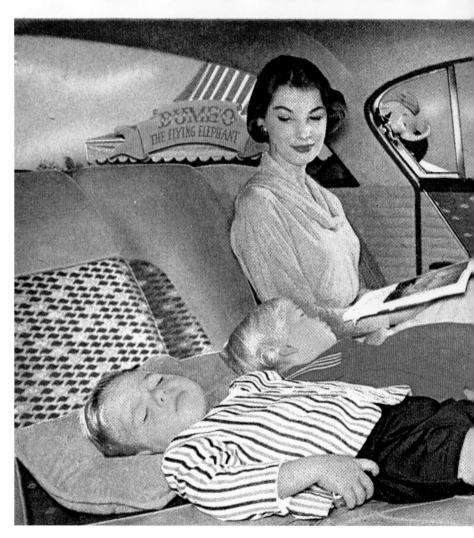

e Children, too,
est Travel Car!

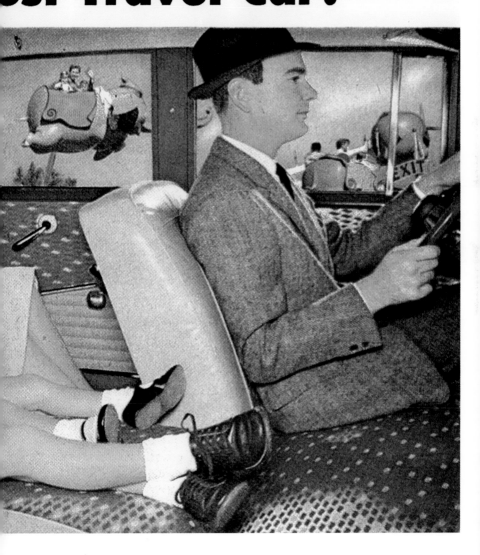

JULIUS SHULMAN MODERNISM REDISCOVERD

Ed. Peter Gössel / Pierluigi
Serraino / Julius Shulman
Hardcover, format: 24.8 x 31.5 cm
(9.8 x 12.4 in.), 416 pp.

WORLD ARCHITECTURE – INTERNATIONAL ST

Ed. Philip Jodidio / Hasa
Uddin Khan / Hardcover
format: 24 x 30 cm
(9.4 x 11.8 in.), 224 pp.

> "TASCHEN books are bright,
> well designed and for what
> they are, puzzlingly inexpensive."
> —SPECIFIER MAGAZINE, *Sydney*

CASE STUDY HOUSES

Ed. Peter Gössel / Elizabeth Smith
Hardcover, format: 33.2 x 25.7 cm
(13.1 x 10.1 in.), 440 pp.

1000 SIGNS

Colors / Hardcover,
format: 15.5 x 21.7 c
(6.1 x 8.5 in.), 320 p

TASCHEN

25th anniversary!

CÉZANNE

Hajo Düchting
Hardcover, format: 24 x 30 cm
(9.4 x 11.8 in.), 224 pp.

GREAT ESCAPES EUROPE

Ed. Angelika Taschen
Softcover, format: 18.8 x 23.8 cm
(7.4 x 9.4 in.), 360 pp.

FRANS LANTING EYE TO EYE

Frans Lanting / Ed. Chris
Eckstrom / Hardcover,
format: 24.7 x 31 cm
(9.7 x 12.2 in.), 256 pp.

POLLOCK

Leonhard Emmerling
Hardcover, format:
24 x 30 cm (9.4 x 11.8 in.),
96 pp.

LONDON INTERIORS

Ed. Angelika Taschen / Text: Jan
Edwards / Hardcover, format:
24 x 31.6 cm (9.4 x 12.4 in.),
280 pp.

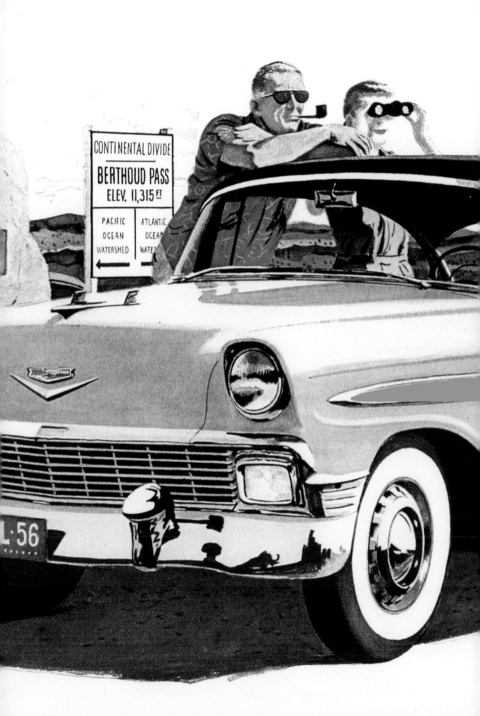

ICONS

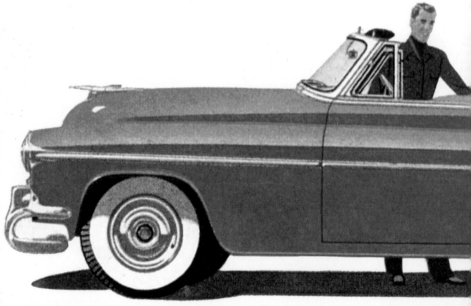